Drawing DYNAMIC COMICS

Drawing DYNAMIC

ANDY SMITH

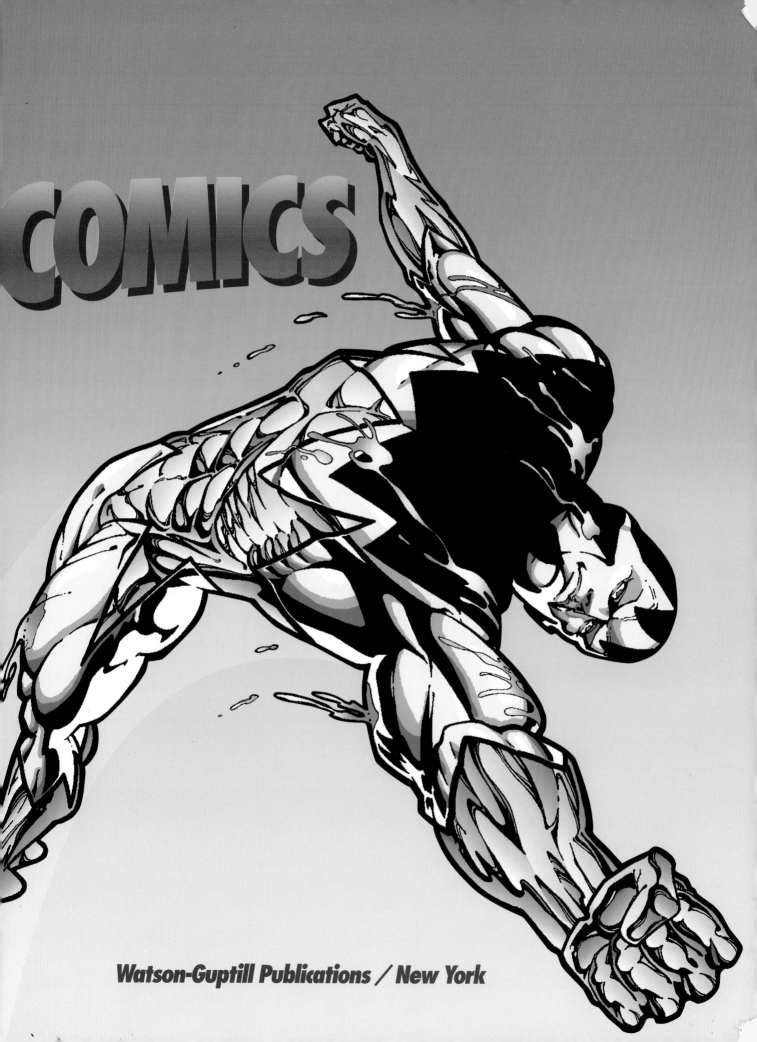

COMICS

Watson-Guptill Publications / New York

To my wife, Helen, and my mom and dad for their support,
and for not going insane while having to deal with me.

Copyright © 2000 by Andy Smith

First published in 2000 by
Watson-Guptill Publications,
a division of BPI Communications, Inc.,
770 Broadway, New York, NY 10003

Library of Congress Card Number: 00-102458

Printed in the United States of America

Third printing, 2000

3 4 5 6 7 8 9 / 08 07 06 05 04 03 02 01

Senior Editor: Candace Raney
Editor: Julie Mazur
Designer: Jay Anning
Production Manager: Hector Campbell

Text set in 10pt ITC Leawood Book

Acknowledgments

I'd like to thank the following people for their help and contributions:

Helen Smith, my wife, for proofreading at the last minute and putting up with all my craziness;

Ron Marz, a fantastic writer with whom I've had the pleasure of working;

Jeff Campbell, Erik Larsen, Kevin Nowlan, George Perez, Brandon Peterson, Bart Sears, Mike Wieringo, and Mike Zeck— all pencilers extraordinaire;

Terry Austin, John Beatty, Randy Elliott, Jordi Ensign, and Tim Townsend—inkers who make pencilers shine;

Brad Vancata, without whom this book would be in black and white;

Mike Atiyeh, for doing a fantastic job coloring the cover;

and Matt Smith, John Guynn, and Melissa Falk, for modeling for me while I acted like a photographer.

CONTENTS

INTRODUCTION 9

Chapter 1
DRAWING IN THREE DIMENSIONS 10

Chapter 2
DRAWING THE FIGURE 24

Chapter 3
THE FIGURE IN ACTION 46

Chapter 4
DRAWING THE HEAD 70

Chapter 5
**USING REFERENCE
MATERIALS 90**

Chapter 6
**DRAWING
THE PAGE 100**

Chapter 7
INKING 122

Epilogue
**BREAKING INTO
THE INDUSTRY 142**

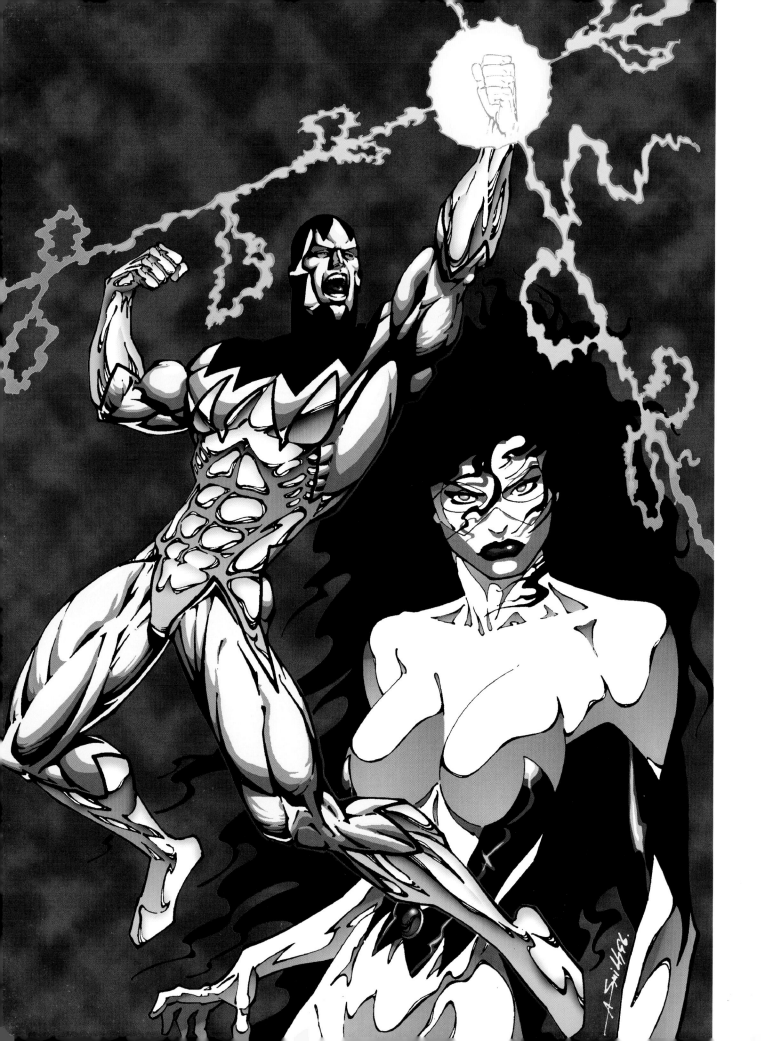

INTRODUCTION

I love comics. I have since I was a little kid. Even then, I loved drawing comics as much as—if not more than—reading them. I remember how my dad would take me to comic book shows and all I'd do is stand and watch the artists draw. I thought I'd never be able to do what those guys were doing. Look, for example, at the drawing at right, which I did when I was about fourteen years old. Hard to believe I've now been drawing comics professionally for close to a decade. See, if I can do it, anyone can!

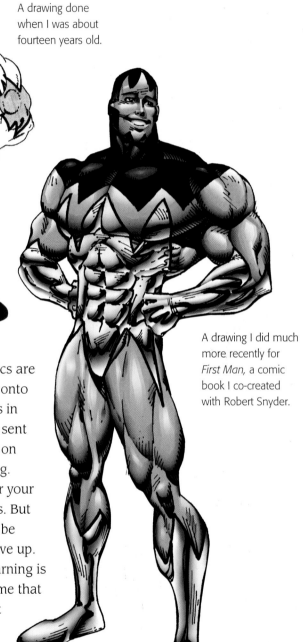

A drawing done when I was about fourteen years old.

A drawing I did much more recently for *First Man,* a comic book I co-created with Robert Snyder.

There are many steps involved in creating a comic book. First, there is a writer who supplies the story. The writer's script is then sent to a *penciler,* who interprets the text into sequential storytelling. The pencils go to a *letterer* (although some comics are lettered with a computer program), who letters the dialogue onto the original art, and then an *inker,* who goes over the pencils in black waterproof ink for reproduction. Finally, the pages are sent to a *colorist* who, obviously, adds color. This book will focus on the two parts of the process I know best: penciling and inking.

The joy of comics is that they allow you to draw whatever your mind can create, whether giant spaceships or huge monsters. But learning to draw comics won't happen overnight. There will be times when you'll get frustrated and will probably want to give up. Don't! The end results are well worth the hard work, and learning is a never-ending process. I once had an art teacher who told me that there are ten thousand bad drawings in each of us. With that in mind, pick up the pencil and start cracking away at them!

Here are two of the characters I created for *First Man:* Apollo and Penumbra. This was the comic book's cover design.

Chapter 1
DRAWING IN THREE DIMENSIONS

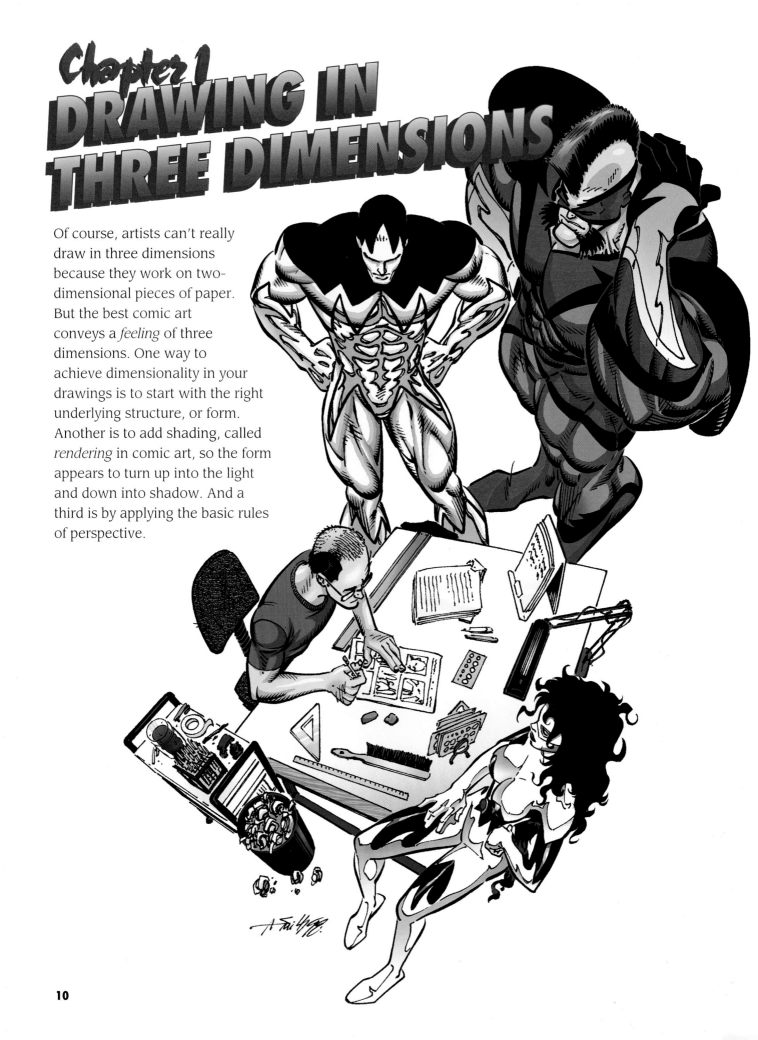

Of course, artists can't really draw in three dimensions because they work on two-dimensional pieces of paper. But the best comic art conveys a *feeling* of three dimensions. One way to achieve dimensionality in your drawings is to start with the right underlying structure, or form. Another is to add shading, called *rendering* in comic art, so the form appears to turn up into the light and down into shadow. And a third is by applying the basic rules of perspective.

THE BASIC FORMS

Most drawings are constructed using one or more of three basic forms: the sphere, the cylinder, and the cube. Visualizing what you want to draw in terms of these basic forms will help give volume and depth to everything you draw, from simple everyday objects to wild inventions of your own.

The Sphere

Three common objects based on the sphere are the basketball, the lightbulb, and the kettle. The dotted line on the lightbulb indicates where the bottom of the sphere would be. The dotted line on the kettle indicates where the top of the sphere would be.

The Cylinder

The glass of water is based on a cylinder that tapers toward the bottom. The coffeepot is a cylinder that first gets progressively wider and then tapers at the bottom. The flashlight is one long cylinder with a short, larger cylinder where the bulb is.

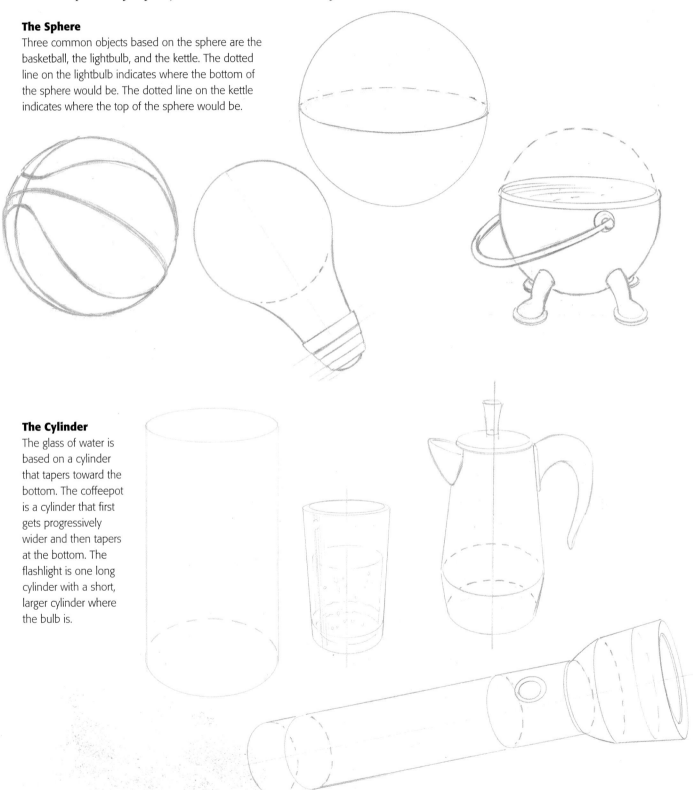

The Cube

An oven is basically a cube, slightly modified. A printer is a more complex object, but its underlying structure is still the cube. The car is built on a stretched-out cube. The tires are built on very short cylinder segments. See, this is easy.

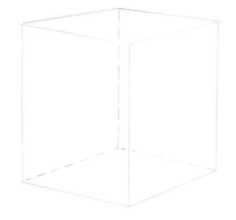

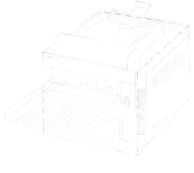

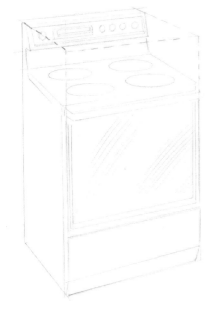

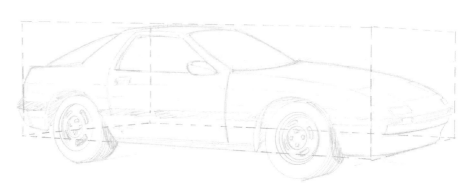

REMEMBER, GOOD STRUCTURE LEADS TO GOOD DRAWING!

From this point on you should always think about depth in your work. Everything you draw should convey a feeling of dimension and volume.

Once you're comfortable using the basic forms to draw familiar objects, you can use them to create virtually anything. Simply decide what you want to draw, then choose which of the basic forms will work best as that object's underlying structure.

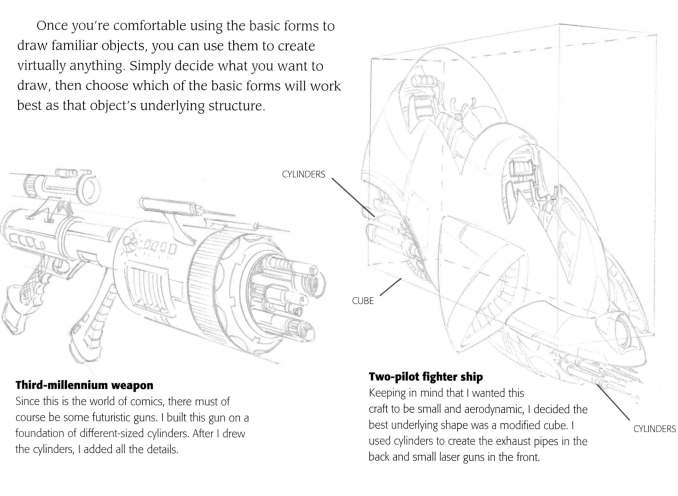

CYLINDERS

CUBE

CYLINDERS

Third-millennium weapon
Since this is the world of comics, there must of course be some futuristic guns. I built this gun on a foundation of different-sized cylinders. After I drew the cylinders, I added all the details.

Two-pilot fighter ship
Keeping in mind that I wanted this craft to be small and aerodynamic, I decided the best underlying shape was a modified cube. I used cylinders to create the exhaust pipes in the back and small laser guns in the front.

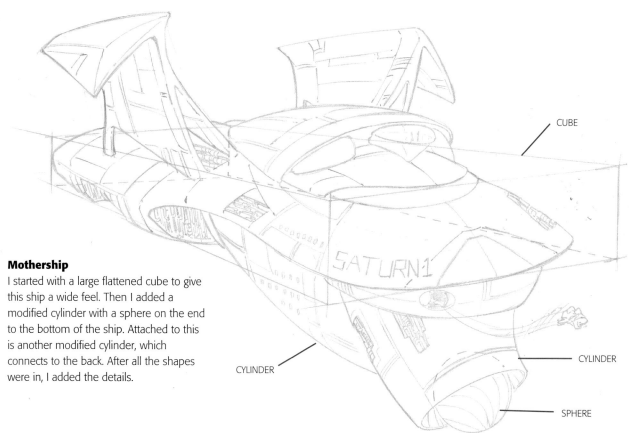

CUBE

CYLINDER

CYLINDER

SPHERE

Mothership
I started with a large flattened cube to give this ship a wide feel. Then I added a modified cylinder with a sphere on the end to the bottom of the ship. Attached to this is another modified cylinder, which connects to the back. After all the shapes were in, I added the details.

LIGHT AND SHADOW

In order to make your forms look "real," you should also show how they interact with light and shadow. As a three-dimensional object turns away from a light source, it darkens. To create this effect in your drawing, you simply darken the relevant parts of each form. This gives the form a sense of solidity and mass. In comic art, this process is called *rendering.*

So how do you do this? Instead of simply separating your forms into areas of white (for forms in the light) and black (for forms in the shadow), most comic book artists use *one-directional feathering* and/or *cross-hatching* to make their transitions subtler and more realistic. One-directional feathering is the process of drawing parallel lines in close proximity, as shown below. Cross-hatching is feathering on top of feathering, with the layers crossing at an angle (also shown below).

One-directional feathering

Cross-hatching

The spheres and figures below show four different rendering techniques, all using one-directional feathering and/or cross-hatching. In all four examples, the light is coming from the upper right, with the lower left portion of the spheres turning into shadow. Study each sphere first to understand the technique, then look to see how the technique is applied to a figure. You can also compare the four figures to get a feel for each technique's particular "look."

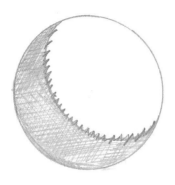

This is a very high-contrast way to render. The shadow is blocked in with solid black, then dark, stubby feathering is pulled out of the shadow to emphasize the point at which the form turns up into the light.

Usually, a rounded form would also show *reflected light,* which is a reflection of light off a surface onto the shadow side. Reflected light is shown by leaving a lighter area in the bottommost part of the sphere, as in the next example (shown below). The rendering technique used here, however, does not show reflected light, making for a moodier, darker piece. Mike Mignola and Kelley Jones are two artists who use this type of rendering.

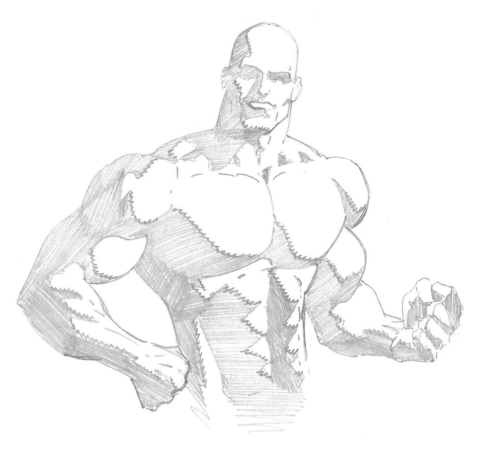

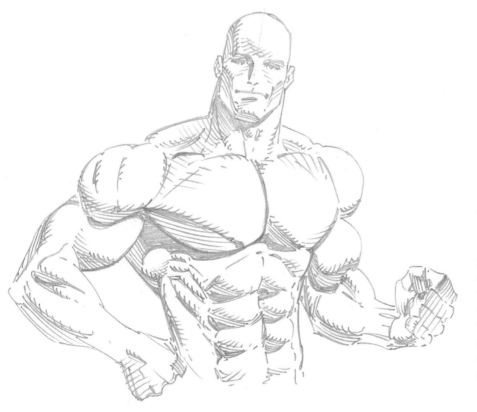

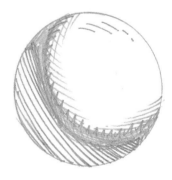

Here solid black is again used to block in the area of shadow, with rougher cross-hatching used along the shadow edge to make the transition between light and shadow smoother than in the previous example. Reflected light is indicated on the underside of the form with one-directional feathering, which fades out of the shadow. This is one of the more popular rendering styles. Check out some of Jim Lee's and Mark Silvestri's work to see examples of this style.

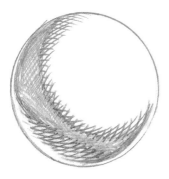

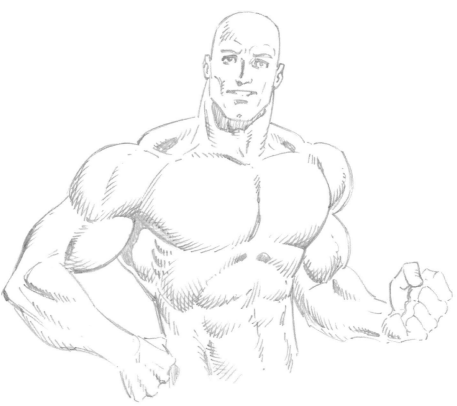

Here is another way to use cross-hatching along the shadow edge, with the lines placed closer together for an even smoother transition. This is also done on the underside of the form, where cross-hatching comes out of the darkened side to indicate the transition into reflected light (which is shown by leaving the white of the paper). Some of John Byrne's and Bart Sears's work uses a style similar to this.

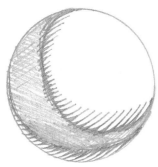

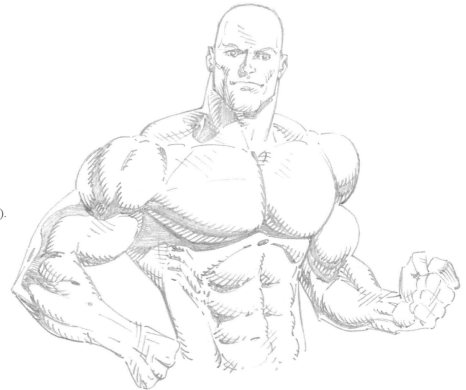

This technique uses one-directional feathering to transition from shadow into light (as well as into reflected light). The feathering is pulled out of the shadow toward the direction from which light (or reflected light) is hitting the form. This style is very clean and crisp. Notice how the feathering pulls smoothly out of the shadow areas. Michael Golden is a fantastic artist to look at for this type of rendering.

PERSPECTIVE

Perspective is another way to create drawings with depth and the feeling of actually existing in space. Drawing in perspective allows you to establish a foreground, middle ground, and background. Every time you draw comic art, whether the picture is of a single person or object, a city scene, or even a battle in outer space, you need to think about perspective.

The Horizon Line

The *horizon line* (often referred to as "eye level") is the line that runs parallel to your line of sight (see below, left). If you are sitting down, the horizon line will be closer to the ground than when you are standing up. When drawing, you can put the horizon line practically anywhere. If you want your scene to look as if it is being viewed from above (a *bird's-eye* view), the horizon line should be close to the top of the picture (see below, right). If you want your scene to look as if it is being viewed from below (a *worm's-eye* view), the horizon line should be closer to the bottom (see page 18).

(see page 18)

OTHER WAYS TO CREATE DEPTH

In addition to using perspective and basic forms, you can also create depth by placing objects relative to one another. Objects on the ground will appear to be nearer when drawn closer to the bottom of the page, and farther when drawn higher on the page. You can also create depth by manipulating the sizes of objects. The smaller an object is relative to other objects in the picture, the farther away it will seem. Finally, just putting one object in front of another creates depth.

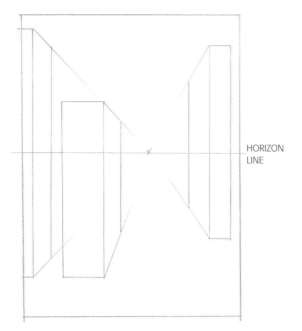

HORIZON LINE

Eye level
The horizon line in this drawing is right in the middle, corresponding to the eye level of a standing person. The two boxes at the left appear closer than the box at the right because they have been drawn farther down in the picture.

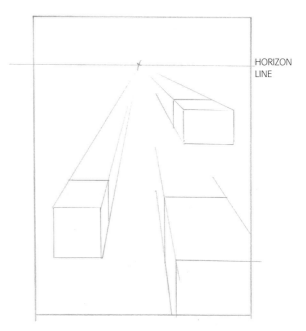

HORIZON LINE

Bird's-eye view
Here, the viewer sees the tops of any objects below the horizon line.

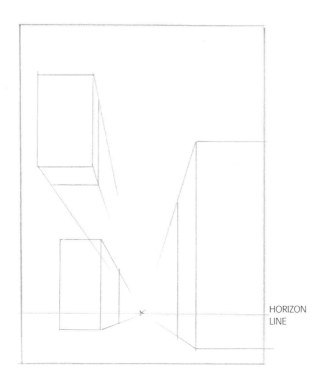

Worm's-eye view
The viewer sees the bottoms of objects above the horizon line. The box on the right has been drawn farther down than the box to its left, so it appears closer. And what about the box "floating" above the horizon line? Because it's bigger than the box just below, it appears slightly closer.

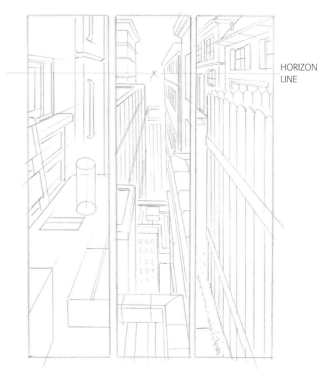

HORIZON LINE

HORIZON LINE

Same horizon line, different scenes
The horizon line in all three of these scenes is high, but only the cityscape (center) is a bird's-eye view. I drew the kitchen scene (left) so the horizon line would correspond to the eye level of a person sitting at one end of the table. In the neighborhood drawing (right), the horizon line is about ten feet above ground level.

You can also use horizon lines to help convey the sizes of figures in your drawing. Suppose, for example, you want all the figures in a picture to appear about the same height. To do this, just give each figure the same relationship to the horizon line.

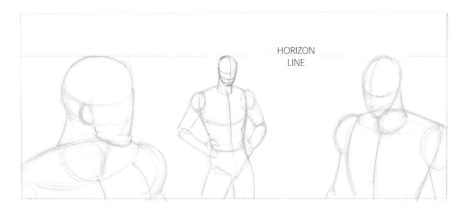

HORIZON LINE

Here there is a high horizon line. The heads of all the figures touch the line, creating the feeling that the figures are all the same size but are simply at different distances from the viewer. Relative size indicates relative distance, so the smallest figure appears farthest away, while the largest figure appears closest. If instead I wanted one figure to appear shorter or taller than the others, I would simply change that figure's relationship to the horizon line, placing that person's head below (for a shorter figure) or above (for a taller figure) the line.

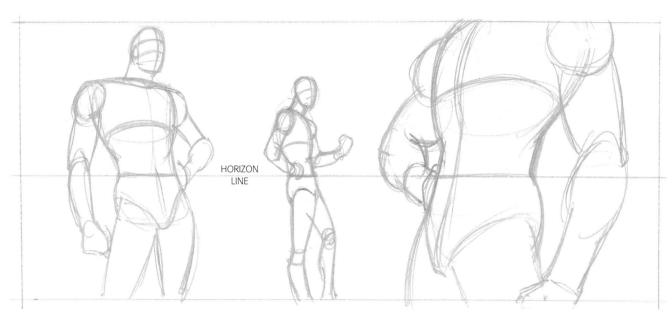

HORIZON
LINE

Here I drew the horizon line slightly lower as I wanted the viewer to be right
in the scene, looking up at the figures. This creates a feeling of intimidation,
even menace. Notice how the line again crosses all the figures at the same
point, this time through the waistline. As before, relative size conveys
distance from the viewer; the smallest, central figure seems farthest away
and the largest, rightmost figure seems closest.

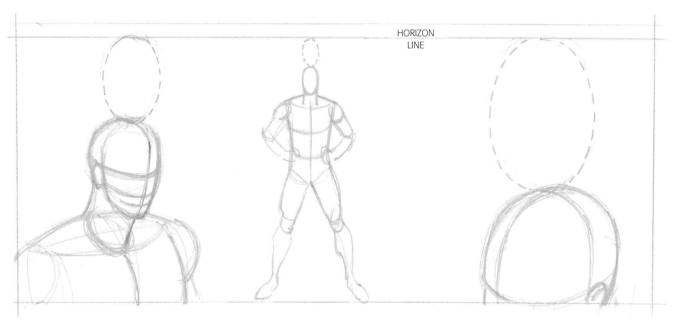

HORIZON
LINE

In this scene I made all the figures one head's length below the horizon
line. Once again, relative size indicates relative distance from the viewer.

One-Point Perspective

There are many systems of perspective used in drawing, each defined by the number of vanishing points used. The *vanishing point* is the point (or points) on the horizon line at which imaginary lines drawn from the edges of objects parallel to one another converge. Note that this does not apply to vertical lines (those parallel to the edge of the picture) or horizontal lines (those parallel to the horizon line), neither of which extend to the vanishing point(s).

In one-point perspective, there is only one vanishing point. This means that if you draw lines extending the edges of objects that are parallel to each other, they will converge at this one point on the horizon line. The vanishing point is always located in the drawing itself, never outside the panel. To summarize:

- There is only one vanishing point.

- The extensions of all lines that are neither horizontal nor vertical converge at the single vanishing point.

- The vanishing point is always somewhere in the drawing itself, never outside the panel.

Because one-point perspective has only one vanishing point, viewers' eyes will naturally be drawn to that point. You can even lead the viewers' gaze to a particular place in the drawing by making it your vanishing point. In both examples here, the vanishing point is marked with a small x.

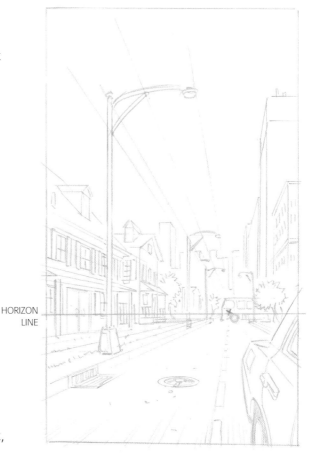

HORIZON
LINE

The vanishing point is at the front of the bus, which is where I want you to look. Once you establish the vanishing point, you can use it to make sure all elements in your drawing are shown in the right perspective. On the light pole shown here, I drew lines to the vanishing point from the light itself, as well as from other key parts of the pole. If I then decided to draw more light poles in the background, these lines would show me exactly how to draw them so they remained proportional.

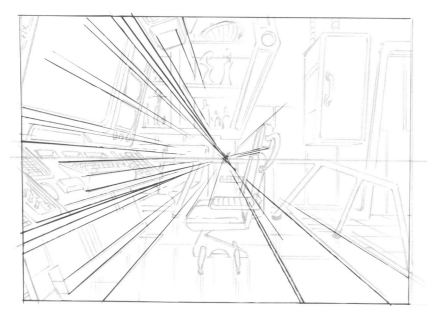

HORIZON
LINE

In this drawing, the vanishing point leads your eye right to the chair in front of the controls. The overlay shows how the lines of the drawing converge at the vanishing point; these are the key lines I used to create the monitor and keyboard.

Two-point Perspective

Now the fun begins! With two-point perspective there are two vanishing points instead of one. In two point perspective:

- There are two vanishing points on the same horizon line, positioned opposite one another. No more than one of the points can be located inside the panel, with the other point off to one side.

- Extensions of the edges of all parallel objects that are neither horizontal nor vertical will converge at one of these two points.

- The closer the two vanishing points are to each other, the more exaggerated the perspective of the drawing.

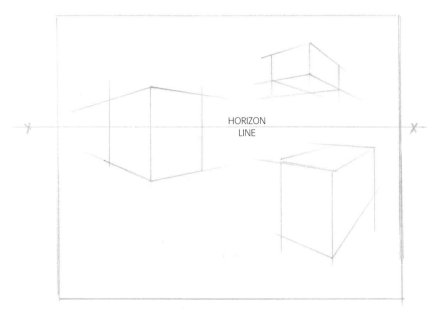

HORIZON
LINE

In this drawing I used simple cubes and put the vanishing points just outside the panel so it would be easy to visually extend the parallel lines and see how they converge at the vanishing points.

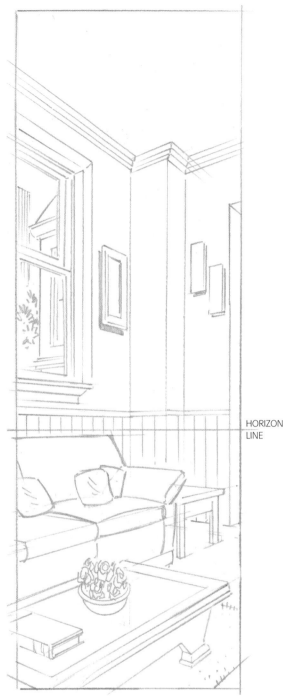

HORIZON
LINE

In most drawings done in two-point perspective, as in this interior scene, the vanishing points are well outside the panel edges. Try taping a piece of paper to either side of the drawing and, using a ruler, extend the edges of objects parallel to each other until they connect with the horizon line. Can you find the two vanishing points?

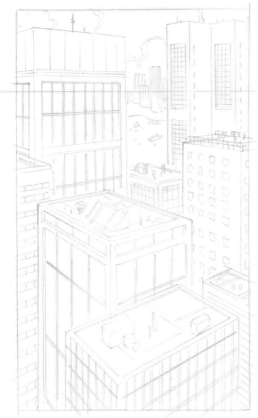

I wanted to create a nice aerial view for this city scene, so I placed the horizon line high in the panel. Try to find the vanishing points. As you will see, the vanishing point on the right is farther from the edge of the panel than the one on the left.

Three-point Perspective

Three-point perspective has three vanishing points and is often used to create an exaggerated sense of height or proximity to the ground, such as when you want to emphasize the height of a building or show how the ground looks to someone high in the air. Lines that are tilted off the horizontal will still converge at one of two vanishing points on the horizon line, while lines that are tilted off the vertical will now converge at a third point above or below the panel.

In three-point perspective:

- Two of the vanishing points are on the horizon line.

- The third vanishing point is either high above or far below the horizon line, depending on whether you want the viewer to be looking up (if it's high above) or down (if it's far below) at the objects in the drawing.

- The closer the third point is to the horizon line, the more exaggerated the perspective will appear.

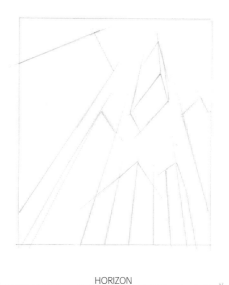

HORIZON
LINE

In this demonstration drawing I placed the horizon line below the panel and positioned two vanishing points close together on the line. The third vanishing point is high above the horizon line and just over the top panel border, making it appear that the viewer is looking up at the scene.

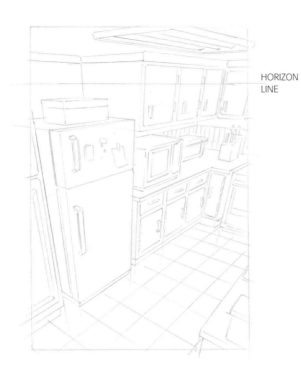

HORIZON
LINE

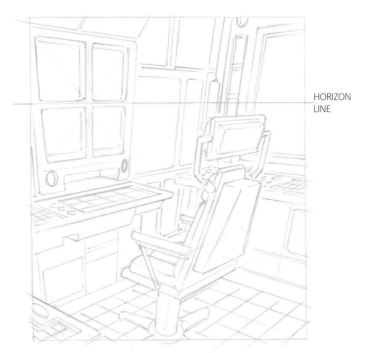

HORIZON
LINE

In this kitchen scene I chose a higher horizon line and placed the two points farther apart (falling off the margins of the page). The third vanishing point is located far below the bottom of the panel, giving the viewer the sense of looking down on the scene.

I wanted to force the perspective a bit more for this control room shot, so I kept the third vanishing point closer to the horizon line (although still below the bottom of the panel). The other two vanishing points, both located on the horizon line, are also outside the panel.

USING PERSPECTIVE YOU CAN REALLY *ZOOM!*

Chapter 2
DRAWING THE FIGURE

Probably the most important aspect of learning to draw comics is learning to draw the figure. And whether you're drawing a muscular superhero, an otherworldly villain, or an ordinary person, you'll need to start with a sound system of proportion and an understanding of anatomy and the figure's basic forms.

PROPORTION

The most reliable way to draw a proportionately correct figure is to use the length of the figure's head as a basic unit of measure and then use it to map out the other body parts. Let's look at how I used this system for three basic types of figures: the average man, the heroic male, and the ideal female.

The Average Man

This man is proportioned like most ordinary people. Using his head as the basic unit of measure, you can see that he is seven and one-third heads tall. On the average person, the torso (the distance from the top of the head to the groin) is longer than the legs; here the torso is four heads while the legs are only three. You should also remember that for both male and female standing figures, the elbows fall just a bit above the waist and the hands fall mid-thigh.

Head lengths mark off the average man's body as follows:

1. the bottom of the chin

2. the bottom of the chest

3. the waistline

4. the groin

5. the tops of the knees

6. halfway down the calves

7. the ankles

This measuring system makes it easy to keep figures consistent from drawing to drawing. For example, this man's legs should always be three heads long. If I were to draw him with longer legs he wouldn't look like the same character.

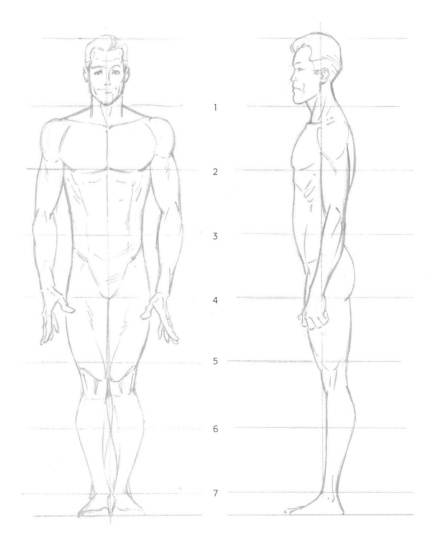

The Heroic Male

To make male heroes look more physically impressive than the average guy, make them proportionately larger—eight and three-quarter heads high. The halfway point of the body should be at the groin, making the legs the same length as the head and torso combined (with the neck an additional one-third of a head length). The hero should also be more muscular than the average man. His shoulders should be set wider apart, his waist thinner, and his chest area should have one head length all to itself.

Head lengths mark off the hero's body as follows:

1. the bottom of the chin

2. the bottom of the chest

3. the waistline

4. the groin

5. halfway down the thighs

6. the bottoms of the knees

7. halfway down the calves

8. the ankles

Committing these points to memory will make figure drawing a lot easier. For example, you now know that on the heroic figure the thigh is always two head lengths long.

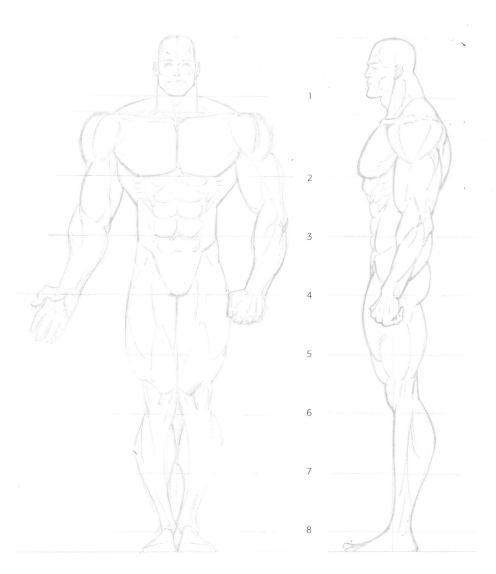

The Ideal Female

The female shown here has been proportioned at seven and three-quarter head lengths. In general, I like to give comic book women long legs; notice that her head and torso are three and one-half head lengths (with the neck a half a head length) while her legs are four. Note that when drawing women you want to keep your lines nice and smooth and avoid angles.

The head lengths for an ideal female fall as follows:

1. the bottom of the chin

2. just above the waist

3. the groin

4. halfway down the thighs

5. the bottoms of the knees

6. halfway down the calves

7. the ankles

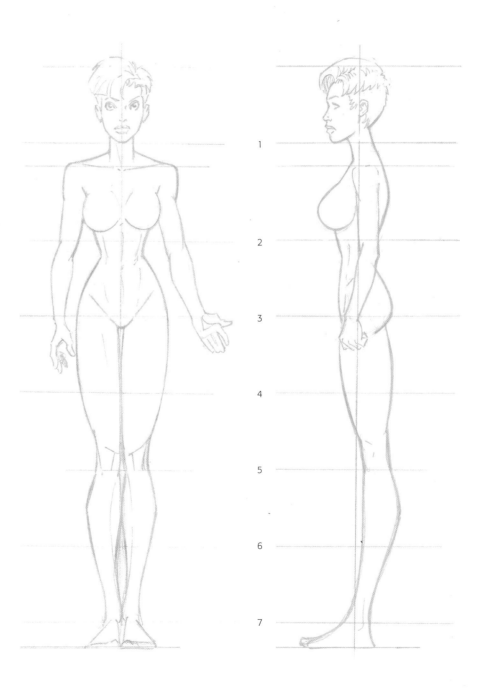

THE BASIC FORMS

The figure, like any other object, can be broken down into spheres, cubes, and cylinders—basic forms that together build a sort of "mannequin," like those shown opposite. The mannequin serves as a foundation, giving your figure a sense of mass, substance, and depth.

Building the mannequin is the most important part of drawing a figure. It is the stage of drawing that tends to take the longest, but if done properly will make your work shine. Study some of your favorite artists. If you look beneath the details of anatomy and costume, you'll be able to see the basic forms they used to create their figures. (It may be useful to review the discussion of basic forms on pages 11–12 before going further.)

The Torso Box

The torso consists of the torso box, which runs from the shoulders to the waistline, and the waist box, which runs from the waistline to the groin. Here are male and female torso boxes as seen from various perspectives. Notice that the female torso boxes taper more toward the waist than those for the male.

The dotted lines, which indicate where forms have been "drawn through," would help you place arms and waist boxes on the figures. Also notice the lines running down and across the front of each torso box, which are used to indicate the vertical centerline of the figure, and the horizontal centerline of the torso box.

> **The dotted lines on these forms indicate their undersides and backs, which the viewer can't see. This process of drawing all sides of a form is called *drawing through*. Drawing through helps you figure out where and how forms connect to one another.**

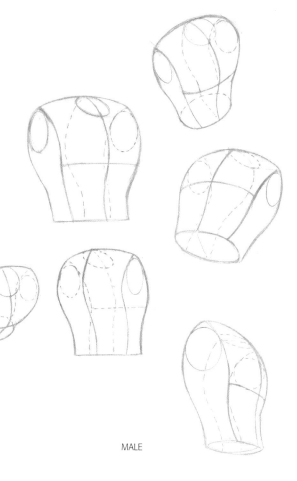

FEMALE

MALE

Here are front and side views of the heroic figure from page 26, now broken down into basic forms. Cylinders are used for the neck, arms, and legs. The joints (elbows, knees, and shoulders) are spheres. The torso is made of modified cubes. Notice that the torso is widest around the chest area and then tapers to the waist.

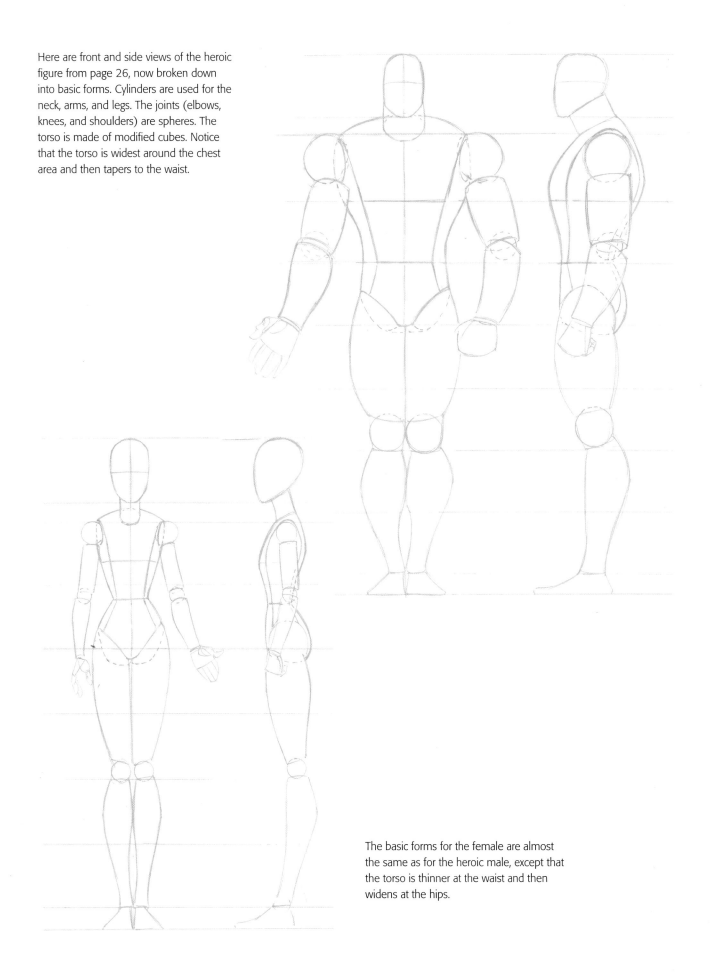

The basic forms for the female are almost the same as for the heroic male, except that the torso is thinner at the waist and then widens at the hips.

The Waist Box

The second part of the torso is the waist box, shown here from various perspectives. Again, notice the differences between the male and female forms: The female forms are narrower at the top and wider across the center.

A good way to remember how this area is formed is to think of a swimsuit bottom. Next time you are in a clothing store, take a look at the mannequins and notice their basic forms. Look at the way dolls are put together and you'll see the same forms put to use.

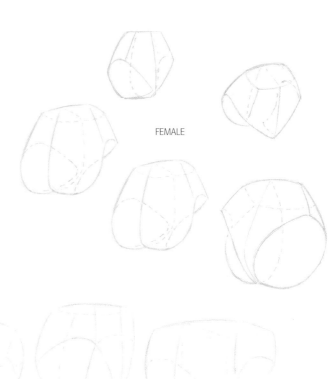

FEMALE

MALE

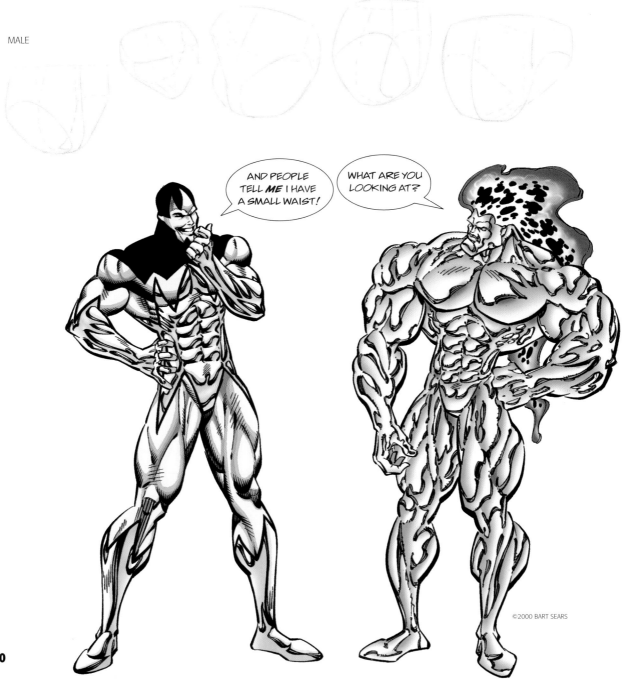

©2000 BART SEARS

Arms

Here are a few of the torso boxes from page 28 with arms attached in various positions. As long as you use the system of proportion you learned earlier to make sure the arms for each character remain the same length, you can manipulate them however you like. Practice tracing some of the torso boxes from page 28 and then adding your own arms.

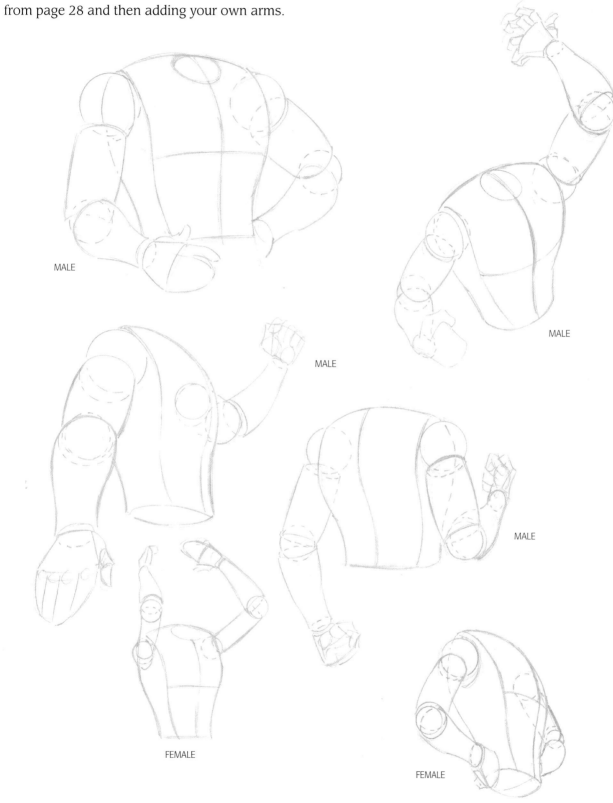

MALE

MALE

MALE

MALE

FEMALE

FEMALE

Legs

The forms of male and female legs are basically the same, but as their waist boxes are significantly different, the resulting forms are easily recognizable by sex. Here I attached legs to a couple of the male and female waist boxes shown earlier.

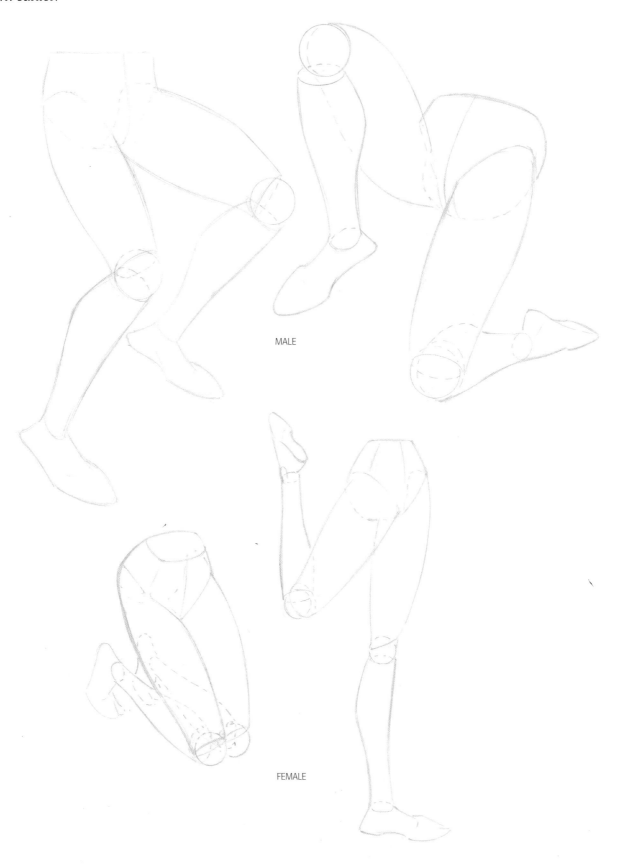

MALE

FEMALE

ADDING MUSCLES

Now that you know how to draw a mannequin, you can start adding muscles to make your figures really come to life! There are lots of muscles in the body, but if you break them down into large groups and simple shapes, drawing them will be a snap.

Front, side, and back views of a heroic male and ideal female are shown below and on page 34. I basically stripped off the skin to expose the muscle underneath. Not a pretty picture. Study the charts to learn the basic shapes of muscles for men and women, and where they are located on the figures. When I was in art school my teacher had us learn the names of almost all the muscles seen here—a study that is way beyond the scope of this book. Besides, knowing the muscles' names won't help you draw them any better, but knowing their shapes and locations on the figure will.

Two good resources for learning about muscles are bodybuilding magazines and fitness shows on television. You can also take a sketchbook and copy the photos in magazines to help commit the basic muscle groups and shapes to memory. And practice drawing with a live model as much as possible to see the muscles in three dimensions.

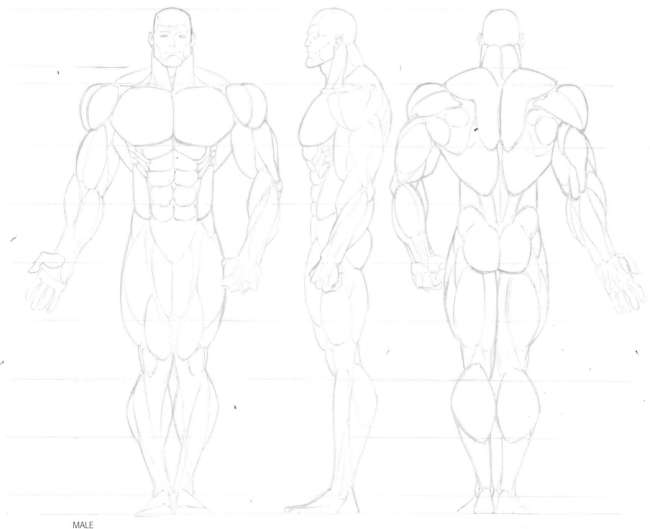

MALE

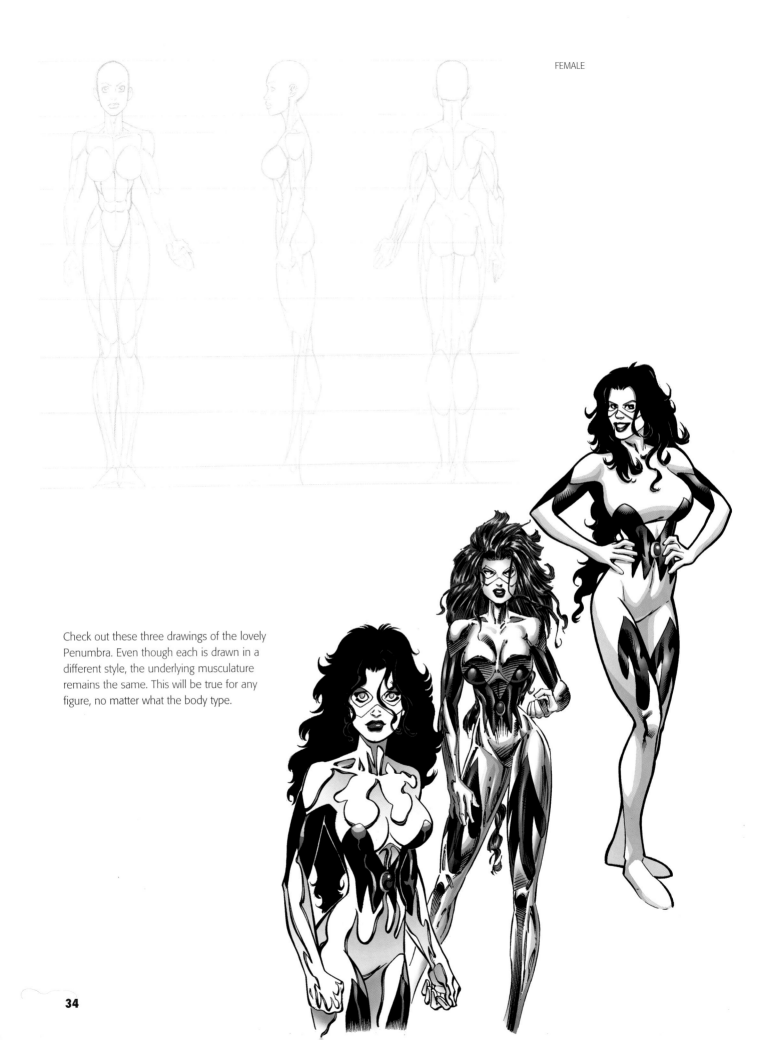

Check out these three drawings of the lovely Penumbra. Even though each is drawn in a different style, the underlying musculature remains the same. This will be true for any figure, no matter what the body type.

You might recognize the drawings below. I took the drawings from page 31 and added muscles. Once you have a basic understanding of where the various muscles connect to the body, you can apply them to any pose.

Use tracing paper to copy some of these muscled mannequins and don't worry if your drawings don't turn out exactly like mine. It takes practice, practice, and more practice to get better. The learning process never ends.

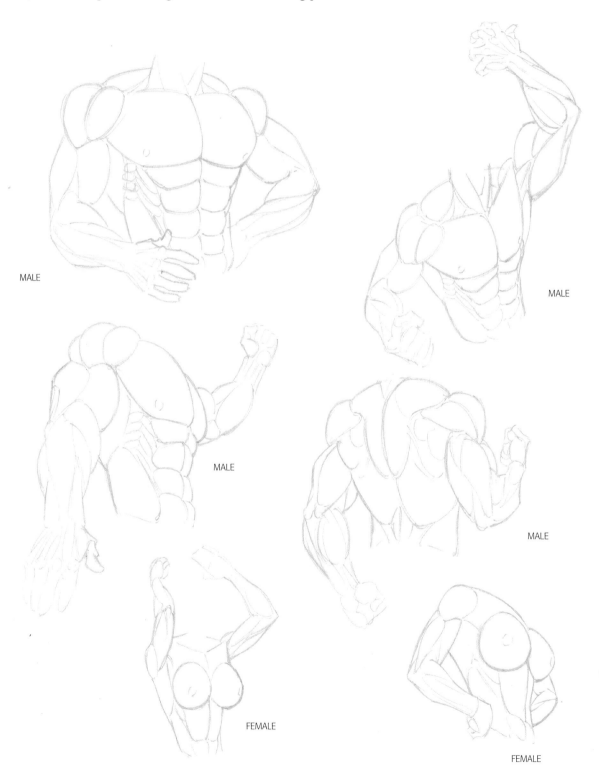

MALE

MALE

MALE

MALE

FEMALE

FEMALE

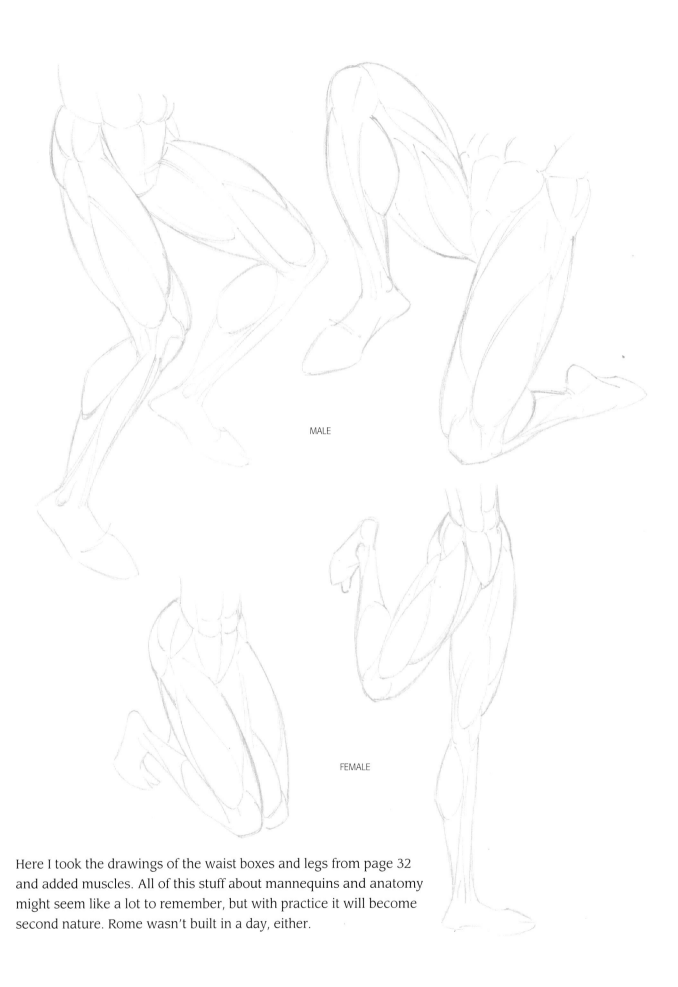

MALE

FEMALE

Here I took the drawings of the waist boxes and legs from page 32 and added muscles. All of this stuff about mannequins and anatomy might seem like a lot to remember, but with practice it will become second nature. Rome wasn't built in a day, either.

DRAWING DIFFERENT BODY TYPES

The proportion system I provided on pages 25–27 is intended to be used as a guide, not a steadfast rule. By expanding what you've learned about basic forms, proportion, and muscles, you can draw any body type you can imagine. As you practice, it might be interesting to study the work of Alan Davis, who varies his male and female body types all the time.

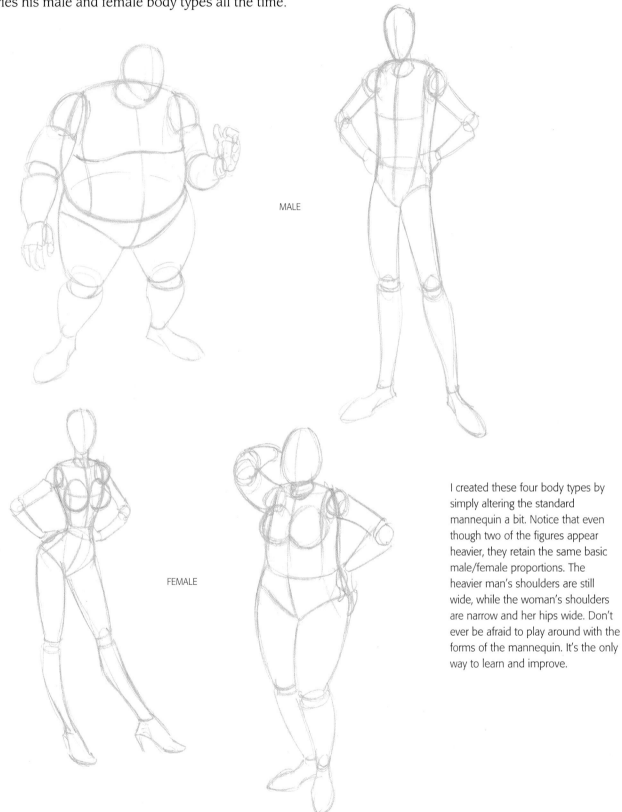

MALE

FEMALE

I created these four body types by simply altering the standard mannequin a bit. Notice that even though two of the figures appear heavier, they retain the same basic male/female proportions. The heavier man's shoulders are still wide, while the woman's shoulders are narrow and her hips wide. Don't ever be afraid to play around with the forms of the mannequin. It's the only way to learn and improve.

Just because the body types are different doesn't mean the muscles change, or that more muscles are added. The muscle groups are the same on any type of person you create. As the shape of the mannequin varies, you simply adapt muscles to fit that particular shape.

MALE

FEMALE

Even when drawing heroic men and women, it's important to give each character a distinctive body type. Apollo and Monarch don't have the same build, for example, and neither should Superman or Batman. It is especially important to do this if you are drawing a team of characters, like the Justice League or the X-men; each member of the group must be consistently identifiable as a particular character.

When designing a character's body type, think about his or her powers. Is the character a super-fast runner? Does he or she have enormous strength? Is the character very agile, like a gymnast?

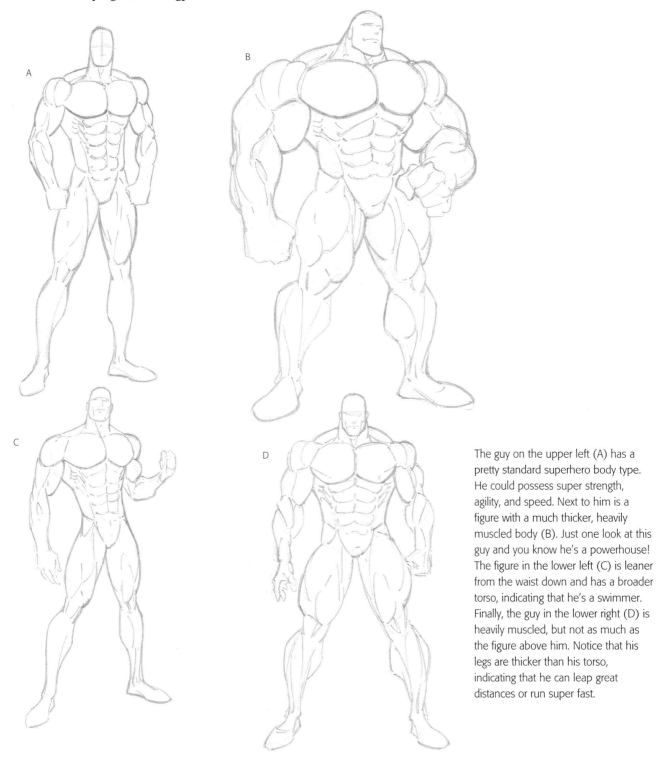

The guy on the upper left (A) has a pretty standard superhero body type. He could possess super strength, agility, and speed. Next to him is a figure with a much thicker, heavily muscled body (B). Just one look at this guy and you know he's a powerhouse! The figure in the lower left (C) is leaner from the waist down and has a broader torso, indicating that he's a swimmer. Finally, the guy in the lower right (D) is heavily muscled, but not as much as the figure above him. Notice that his legs are thicker than his torso, indicating that he can leap great distances or run super fast.

Women characters should also have distinctive body types. Study the four female figures shown here. Try to imagine how their characters and strengths might differ.

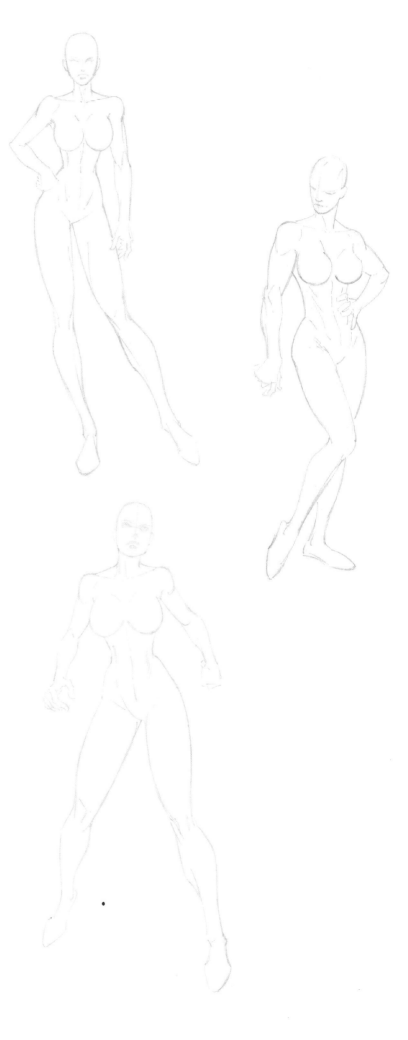

CLOTHING

Once you have a muscled, well-proportioned figure, you'll most likely want to dress him or her in some kind of costume. You'll also be drawing normal people, and a major part of drawing everyday people convincingly is to portray their clothing accurately.

When drawing clothing, the most important thing is to show how the clothing hangs on the figure. There are stress points on the body from which clothing hangs and pulls—the shoulders, neck, elbows, waist, groin, and knees—and you show this by indicating how the fabric wrinkles.

It's best to keep wrinkles simple, with a nice flow to them, but it's important to note that not all types of fabric wrinkle the same. Clothing will also wrinkle differently depending on how it fits the figure. I always keep catalogs from department stores on hand to see how various fabrics and cuts fall on the figure.

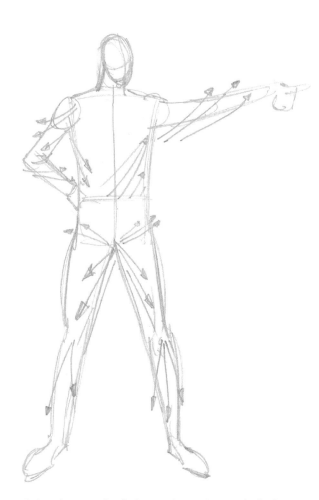

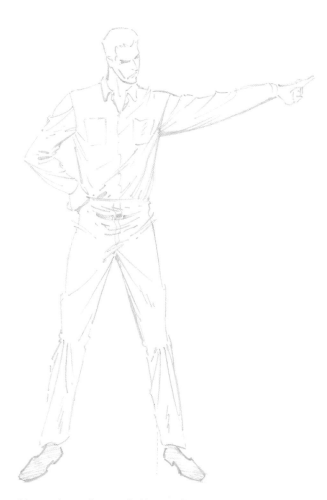

Clothing hangs and pulls from various points on the body, as shown here. This figure's trousers pull away from the groin and inner thighs and hangs down off the kneecaps. Because this man's left arm is outstretched, his shirt pulls up from his waistband and the underside of his sleeve in the direction he is pointing. On his right side, wrinkles flow from the shoulder, armpit, and elbow.

This man is wearing a typical button-down shirt and slacks. This type of shirt is usually made of a lightweight material like cotton, which tends to wrinkle a lot. Notice how the wrinkles flow in the same directions as those shown by the arrows in the figure at left.

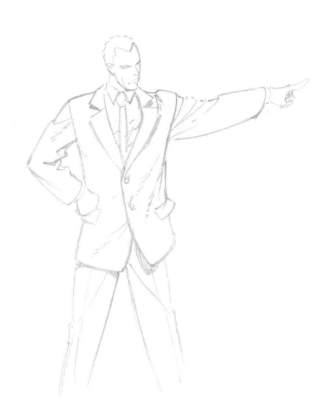

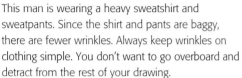

This man is wearing a heavy sweatshirt and sweatpants. Since the shirt and pants are baggy, there are fewer wrinkles. Always keep wrinkles on clothing simple. You don't want to go overboard and detract from the rest of your drawing.

This man is wearing your typical business suit. A suit jacket like this one usually only shows wrinkles in the sleeves (unless the character is sitting). The rest of the jacket will just hang off the shoulders with very few wrinkles. When drawing dress pants, keep wrinkles to a bare minimum to help convey a nice, pressed feeling. Remember, less is better.

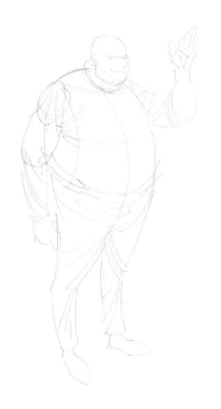

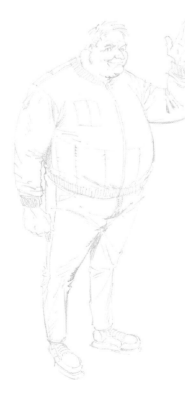

This example is of a rather portly fellow. On the left is an initial stage of the drawing, with slight indications marked for how the wrinkles should flow. To the right is the finished drawing.

This guy's largest mass is in his belly region, so that's where his clothes will fit the tightest. Slight indications of wrinkles around the tummy are all that are necessary.

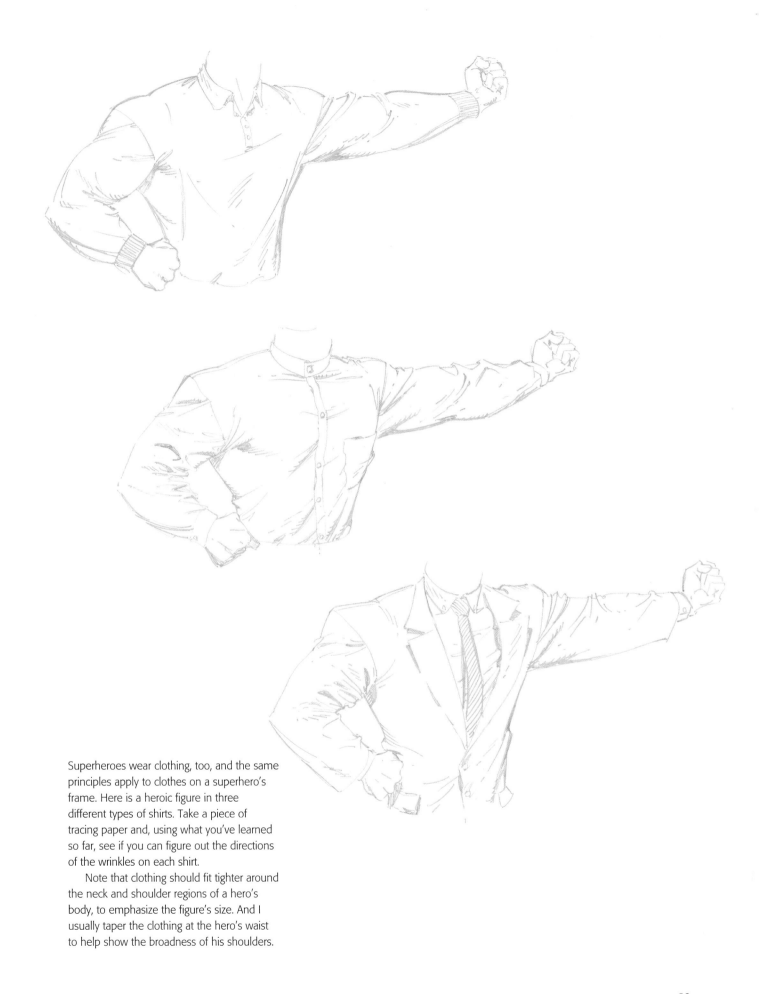

Superheroes wear clothing, too, and the same principles apply to clothes on a superhero's frame. Here is a heroic figure in three different types of shirts. Take a piece of tracing paper and, using what you've learned so far, see if you can figure out the directions of the wrinkles on each shirt.

Note that clothing should fit tighter around the neck and shoulder regions of a hero's body, to emphasize the figure's size. And I usually taper the clothing at the hero's waist to help show the broadness of his shoulders.

Here I've taken the female figures shown on page 40 and dressed them up a bit. As silly as it might sound, always vary the clothing your characters wear. I've seen work at conventions in which all the ordinary people are dressed alike. Pay attention when you go out, whether to the mall or a fast-food restaurant, and take note of what people are wearing. It also helps to have the latest clothing catalogs on hand for reference.

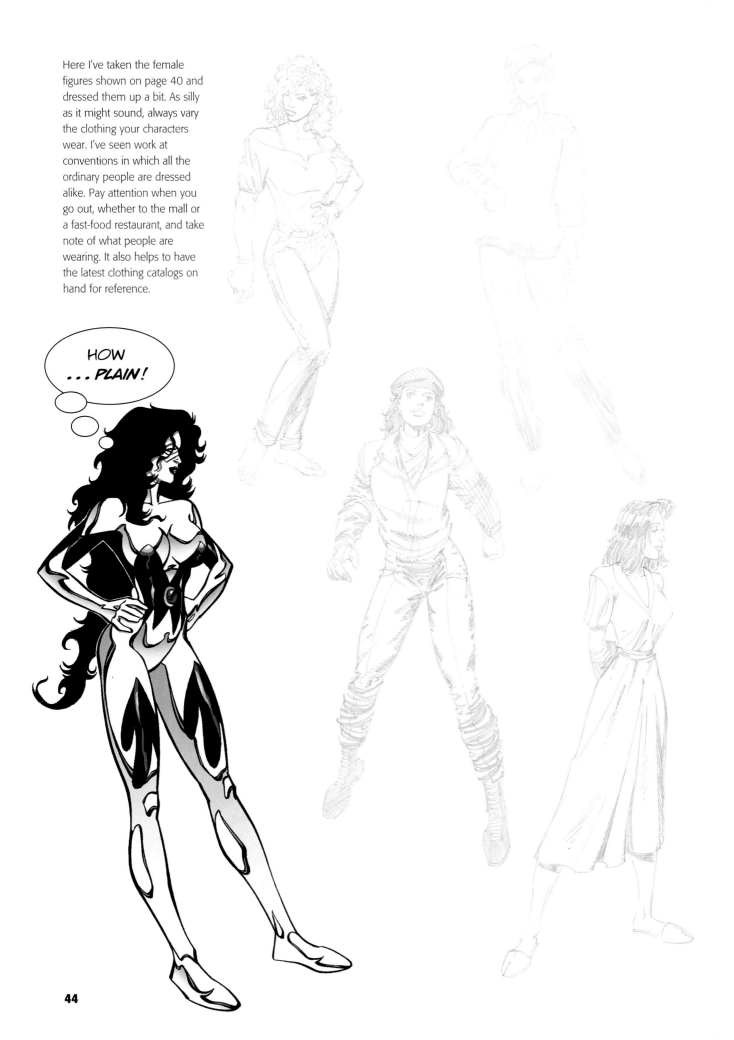

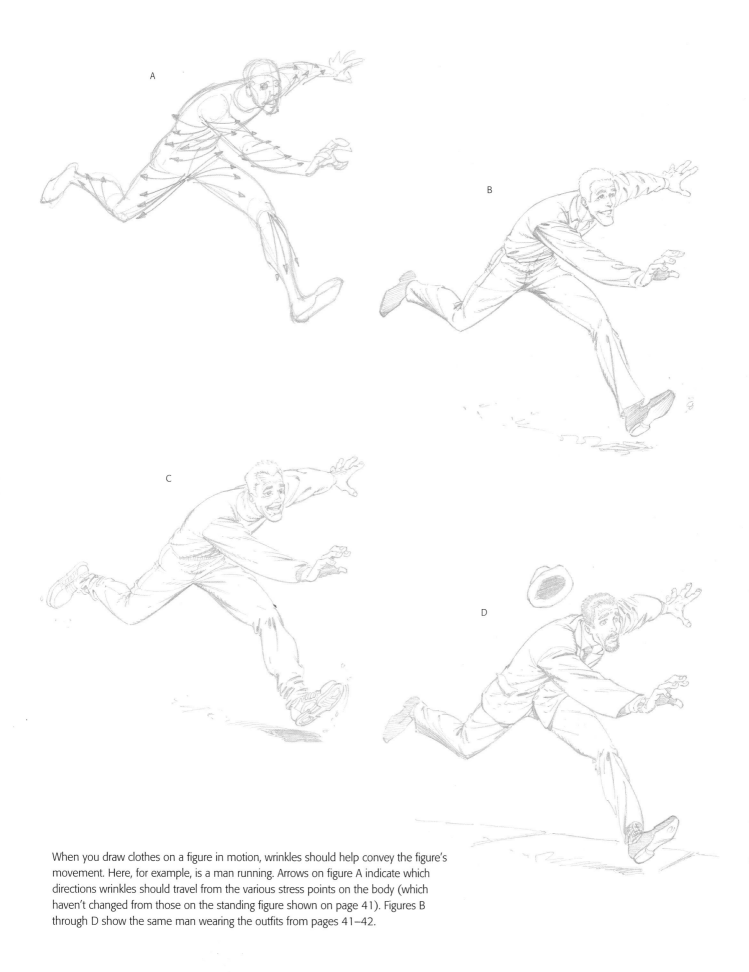

When you draw clothes on a figure in motion, wrinkles should help convey the figure's movement. Here, for example, is a man running. Arrows on figure A indicate which directions wrinkles should travel from the various stress points on the body (which haven't changed from those on the standing figure shown on page 41). Figures B through D show the same man wearing the outfits from pages 41–42.

Chapter 3
THE FIGURE IN ACTION

You can't draw comics without drawing figures in action. Action communicates feeling, excitement, movement, and energy. Comic book characters are never standing still; they are always acting and reacting, and using body language to express their emotions.

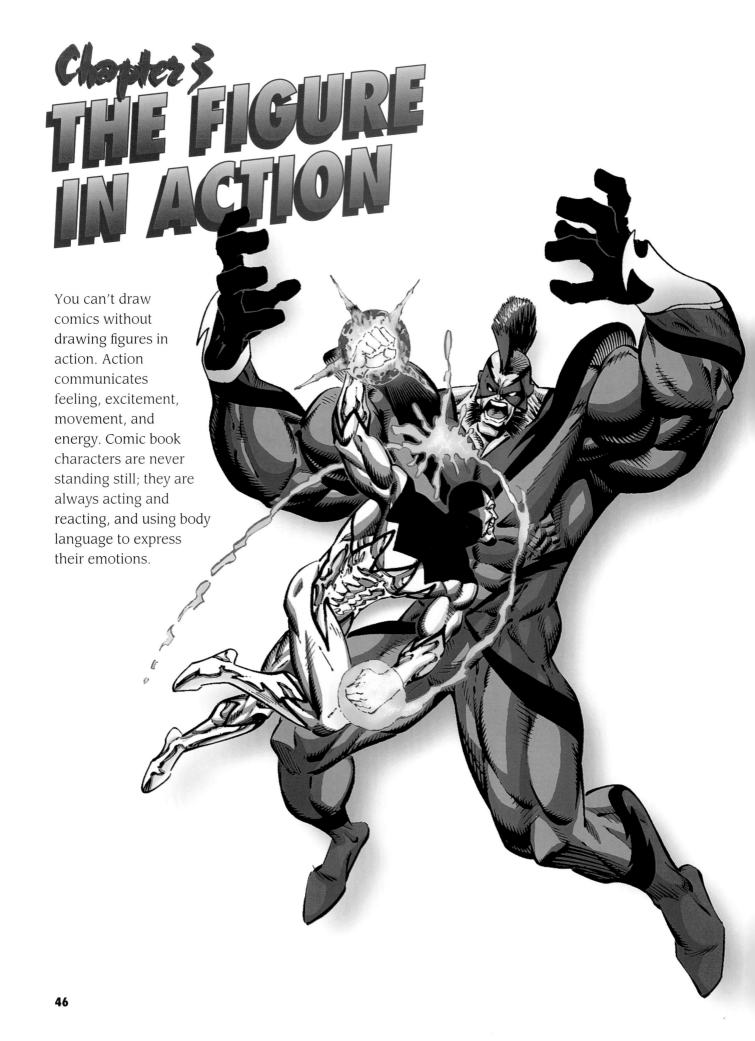

THE LINE OF ACTION

To start drawing a figure in action you need to start with the *line of action.* The line of action, sometimes called the *centerline,* is an imaginary curved line that runs down the center of a figure and determines its flow and the swing of its movement. Every figure has a line of action, whether it's a guy waiting for a bus or a hero flying to an emergency.

I recommend drawing the line of action first, then building your figure around it. Sketch the figure in loosely, keeping the line of action in mind. This is called *gesture drawing:* It sets the tone of the figure's action and is thus one of the most important parts of the drawing. Practice by filling up sketchbooks with loose figure drawings; the more you do the better you'll get.

Study the drawings that follow to see how the line of action fits into each drawing. To help you, I've copied the line of action next to each figure.

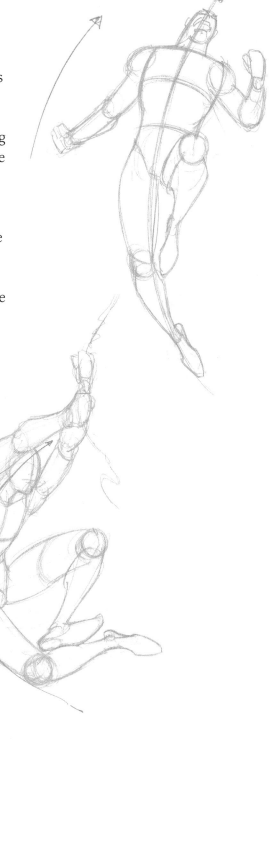

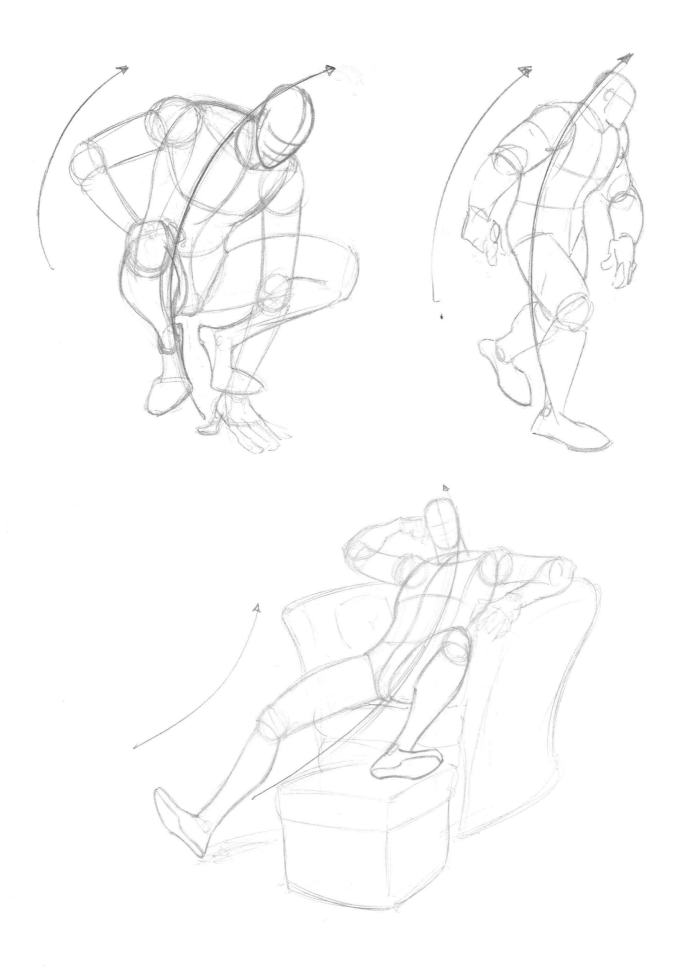

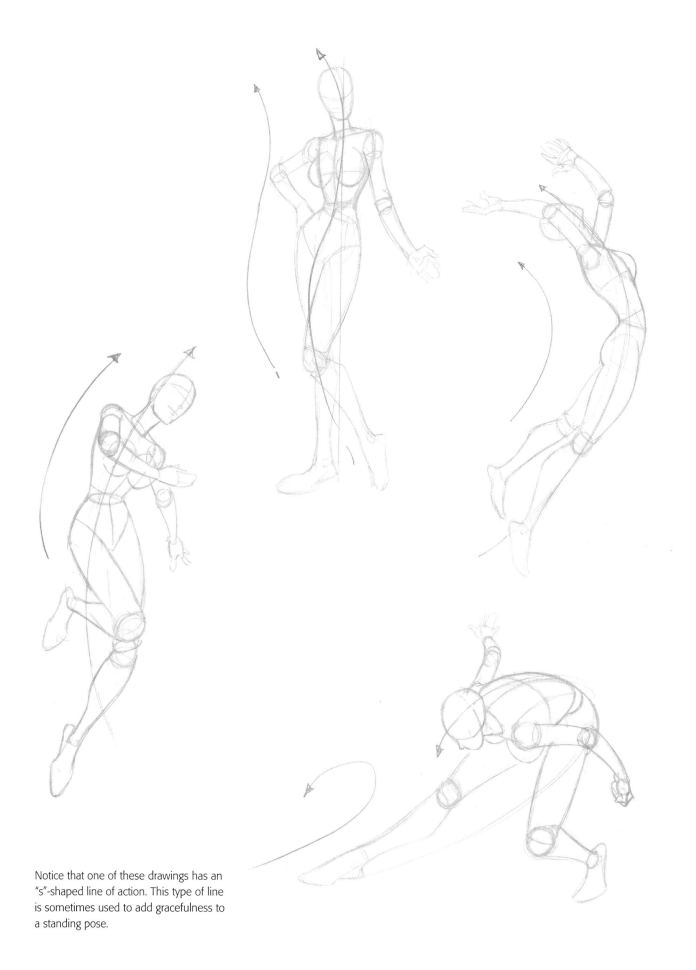

Notice that one of these drawings has an "s"-shaped line of action. This type of line is sometimes used to add gracefulness to a standing pose.

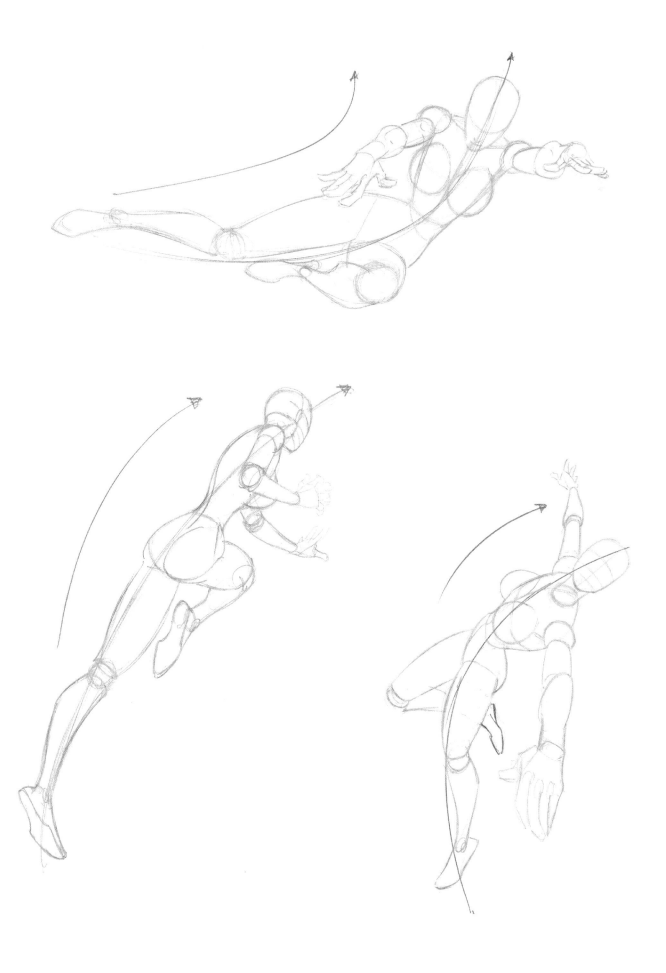

BALANCE

A balanced figure is one with its weight distributed equally, whatever it is doing. As we lean or shift weight in one direction, our bodies must compensate to keep us from falling over. Balance is an essential part of drawing any figure, and without it a figure will look awkward and unnatural.

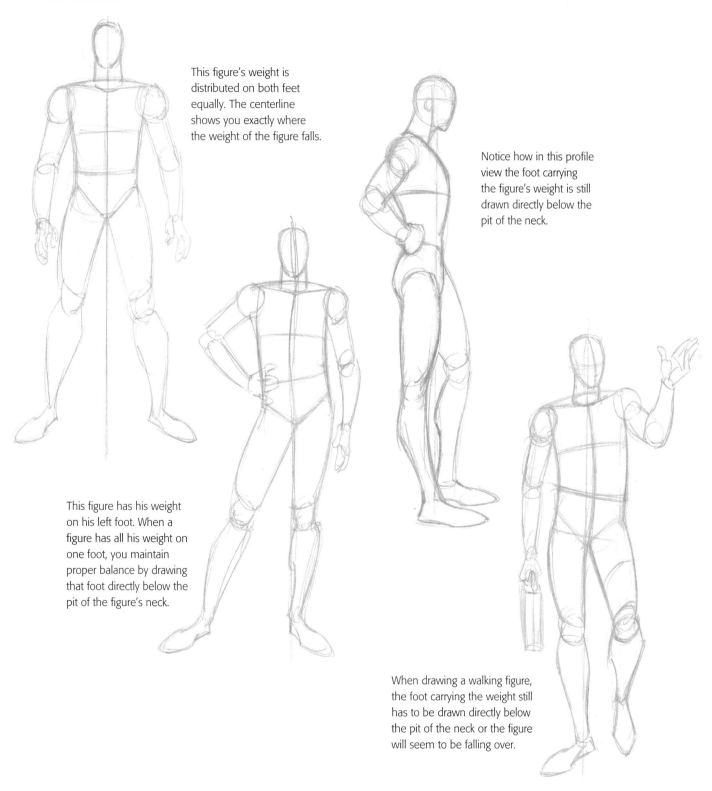

This figure's weight is distributed on both feet equally. The centerline shows you exactly where the weight of the figure falls.

Notice how in this profile view the foot carrying the figure's weight is still drawn directly below the pit of the neck.

This figure has his weight on his left foot. When a figure has all his weight on one foot, you maintain proper balance by drawing that foot directly below the pit of the figure's neck.

When drawing a walking figure, the foot carrying the weight still has to be drawn directly below the pit of the neck or the figure will seem to be falling over.

Twisting and Turning

Any figure in action will incorporate some kind of twist or turn of the body. This is true for even the subtlest of actions. Stand up and walk across the room and you'll notice that your body is twisting. As you put one leg out in front of you, your opposing arm will swing out in front to counterbalance your body, slightly twisting it. In the same way, when a hero throws a punch the leg opposite the punching arm will come forward to balance his body, thus twisting it. As the torso twists, muscles on one side compress, or shorten, while those on the opposite side stretch, or lengthen.

Think of the torso in its simplest terms: the torso box as an elongated cube and the waist box as a cube. Now imagine that the bottom corners of the torso box and top corners of the waist box are connected with string. To help your visualization, take a couple of wooden blocks and connect them this way. Turn and twist the cubes, then sketch from what you see.

Below and opposite are some examples of twisting and turning torsos, both as simplified cubes and more realistically drawn figures.

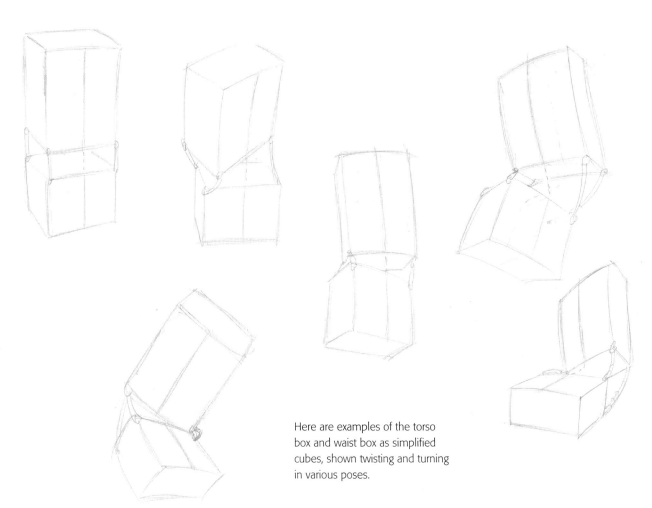

Here are examples of the torso box and waist box as simplified cubes, shown twisting and turning in various poses.

Here are the same poses, this time drawn with more realistic musculature. Notice how the muscles compress (shorten) and stretch (lengthen) on opposite sides of each figure.

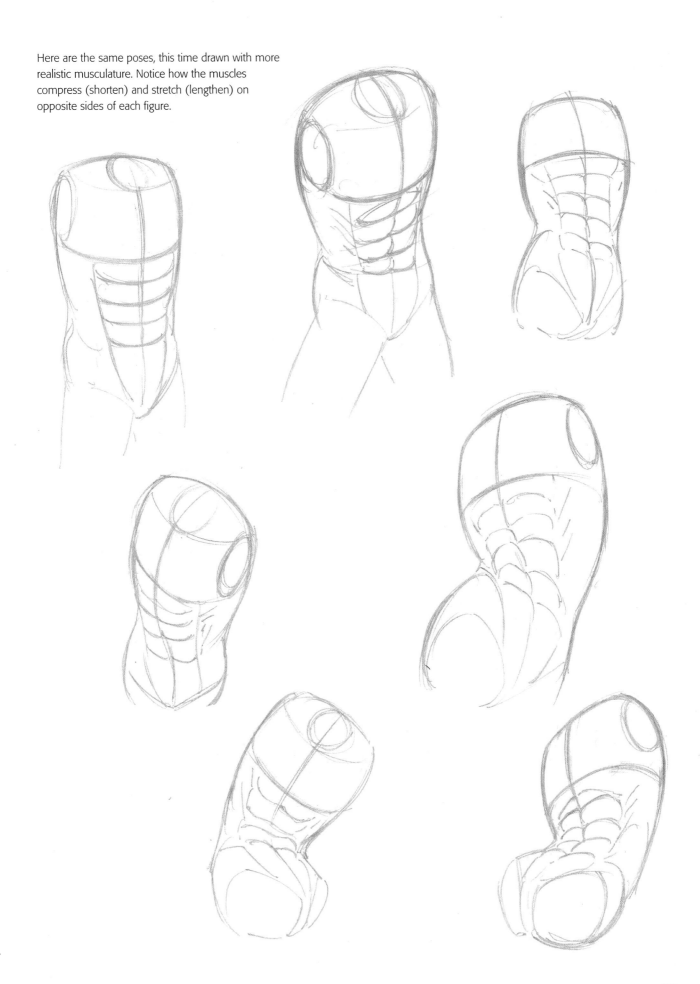

FORESHORTENING

Almost any character you draw will be turning, twisting, moving toward or away from the viewer, or angled in some way. In other words, it will be foreshortened. *Foreshortening* is the technique of making parts of a figure appear to recede or come forward. We've all seen a comic book fist that seems to jump toward us off the page: That's foreshortening!

Foreshortened forms are still based on the basic shapes you learned earlier. The important difference is that as forms tilt away from us, they appear shorter (and thus the term "foreshortening"). The more extreme the tilt, the shorter the form. Foreshortening can be subtle or exaggerated, depending on the desired effect.

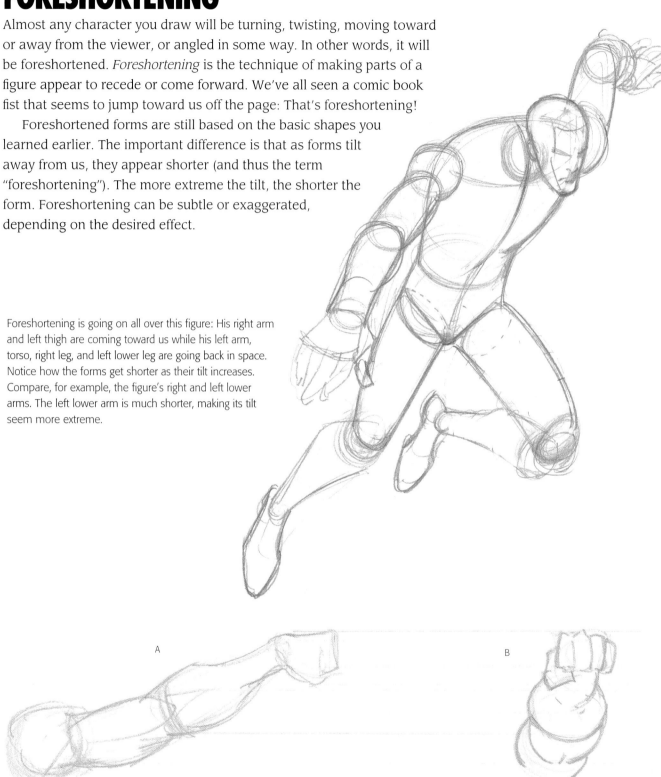

Foreshortening is going on all over this figure: His right arm and left thigh are coming toward us while his left arm, torso, right leg, and left lower leg are going back in space. Notice how the forms get shorter as their tilt increases. Compare, for example, the figure's right and left lower arms. The left lower arm is much shorter, making its tilt seem more extreme.

A

B

Here's a simple way to draw forms that come directly forward toward the viewer, like the fist shown here (B). Just draw the part of the figure in a flat profile, as above (A). Then use a ruler to draw lines across the page at the major points of the form. Use those lines as guides to draw the same forms from a flat front view and you'll have a foreshortened arm (B).

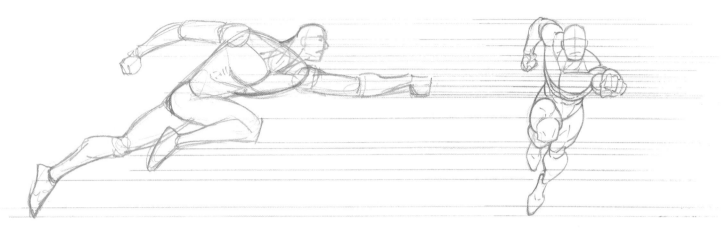

Here the same method is used to draw a foreshortened running figure.

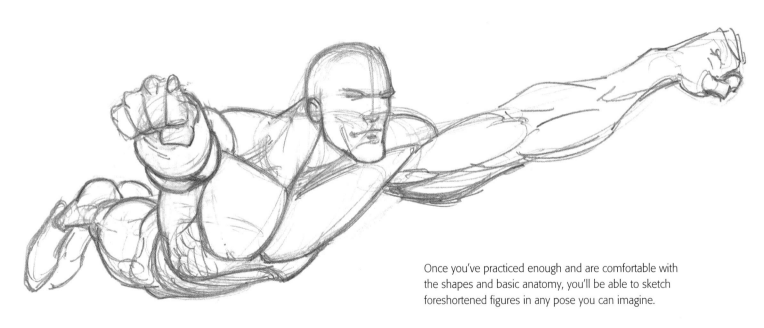

Once you've practiced enough and are comfortable with the shapes and basic anatomy, you'll be able to sketch foreshortened figures in any pose you can imagine.

REALISM VERSUS EXAGGERATION

When drawing comics, you should exaggerate the actions of your figures to give them a better sense of movement and animation. I've put together a few examples of realistic actions and their exaggerated counterparts, shown below, opposite, and on page 58. Study them, copy them, and try to come up with some of your own.

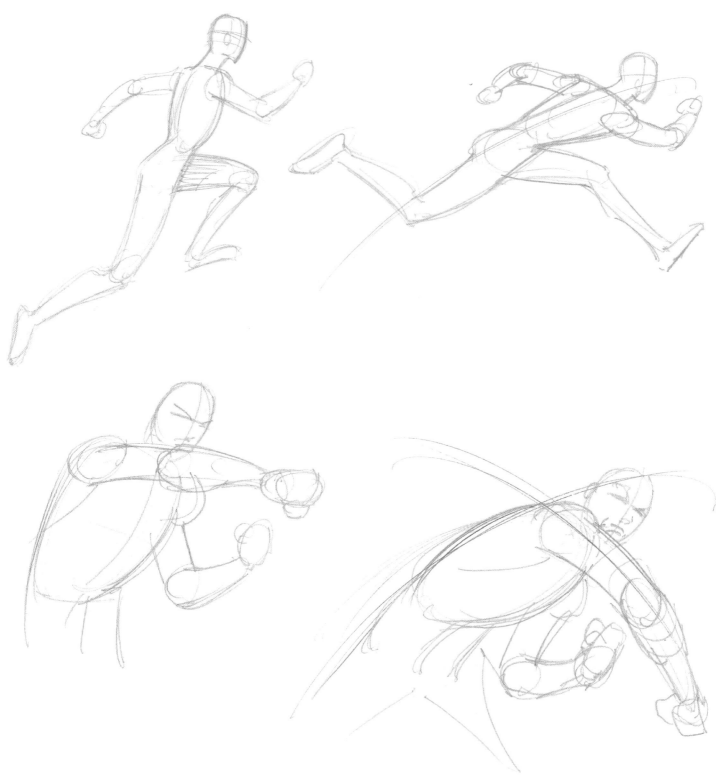

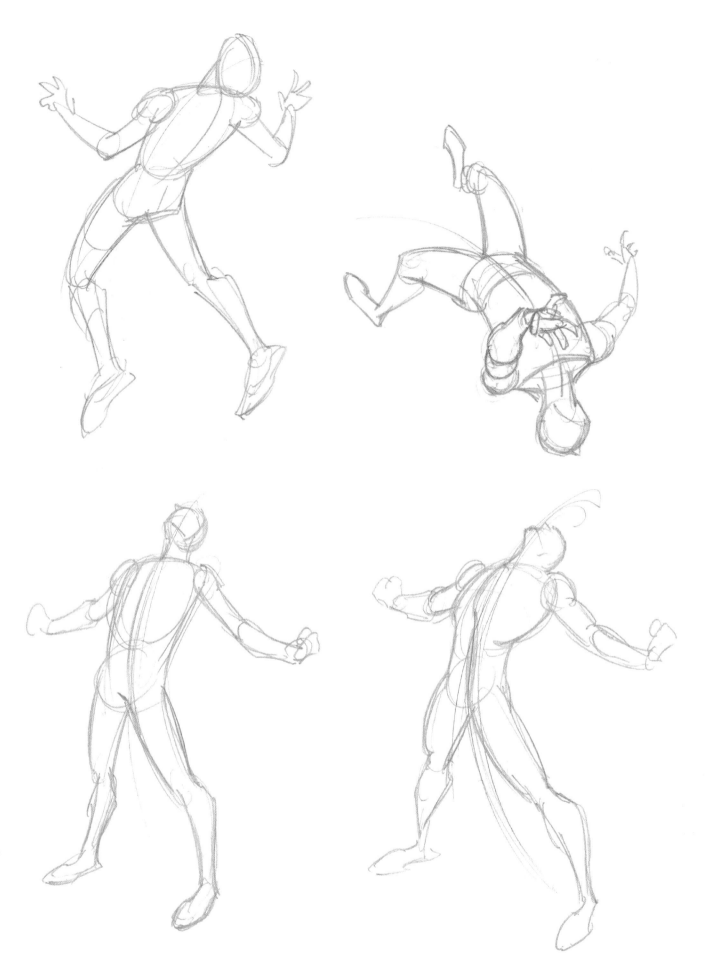

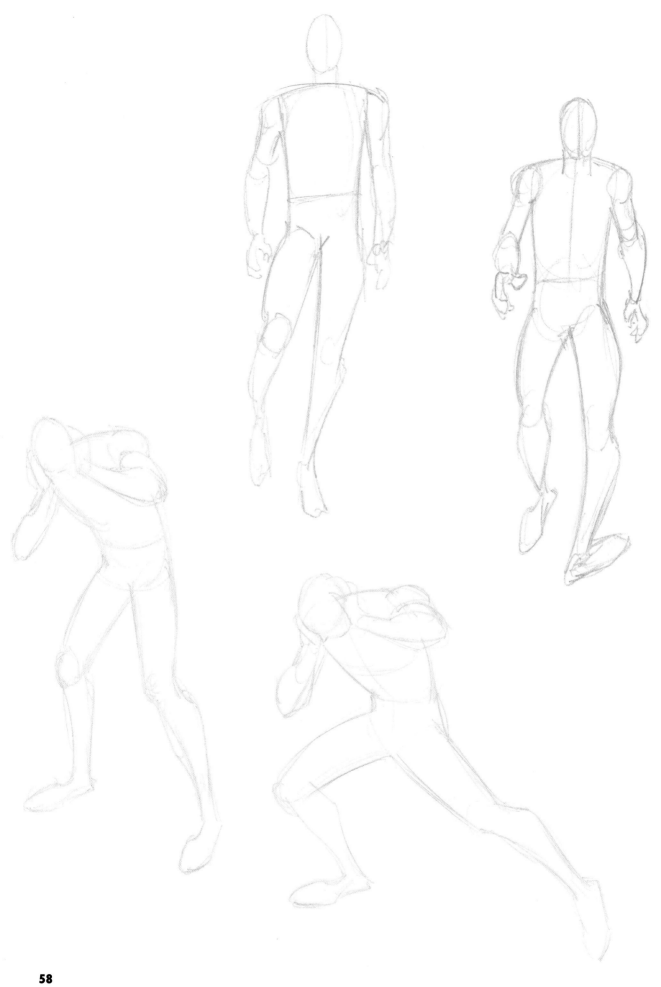

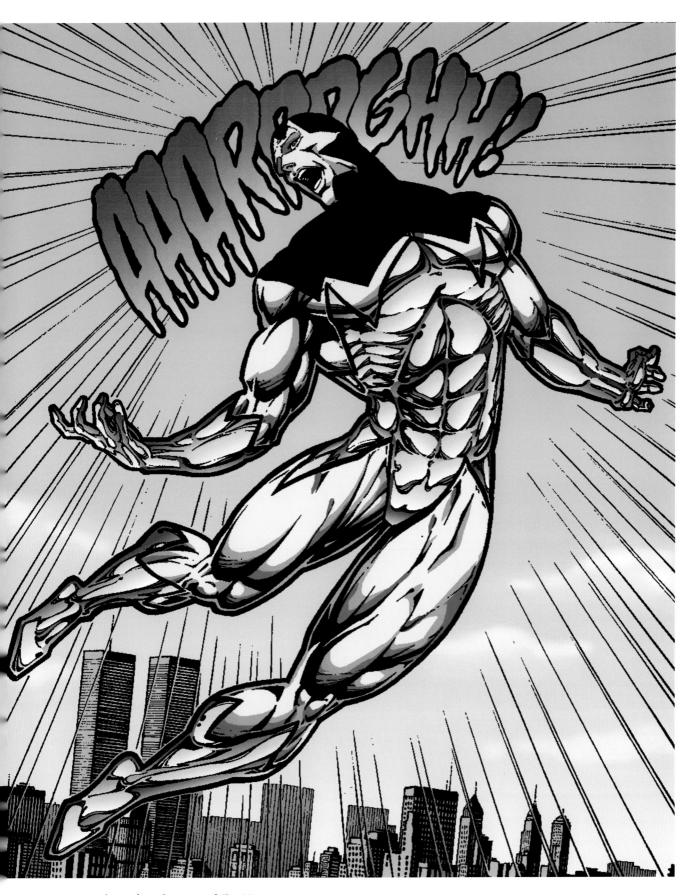

An exaggerated pose from the pages of *First Man*.

PUTTING IT ALL TOGETHER

Now the fun part: putting all the information you've learned so far to use! The following step-by-steps show you how to draw several of the characters I created for *First Man*: Penumbra, Apollo, Monarch, Blubberboy, and Stick. Take out some paper and follow along. Feel free to trace any of the steps if it will help you learn. Once you feel comfortable working with my drawings, practice coming up with your own figures.

Remember, don't rush. Each step builds on the previous one, so take your time before moving from one to the next. Drawing isn't a speed contest. Everyone draws at his or her own pace. What matters is the end result.

Penumbra

We'll start with the ever lovely Penumbra. Here, as in every drawing, there are four basic steps: laying down the gesture, building the mannequin, adding surface anatomy, and refining your drawing by adding costume details and rendering.

1. Draw the gesture
Starting with the line of action, do a quick gesture drawing.

2. Build the mannequin
Block in the basic forms of the figure (see page 29) over your gesture drawing, remembering to draw through each form. Pay attention to the proportion of the figure and how the different forms relate to one another. Start roughing in the features of the face.

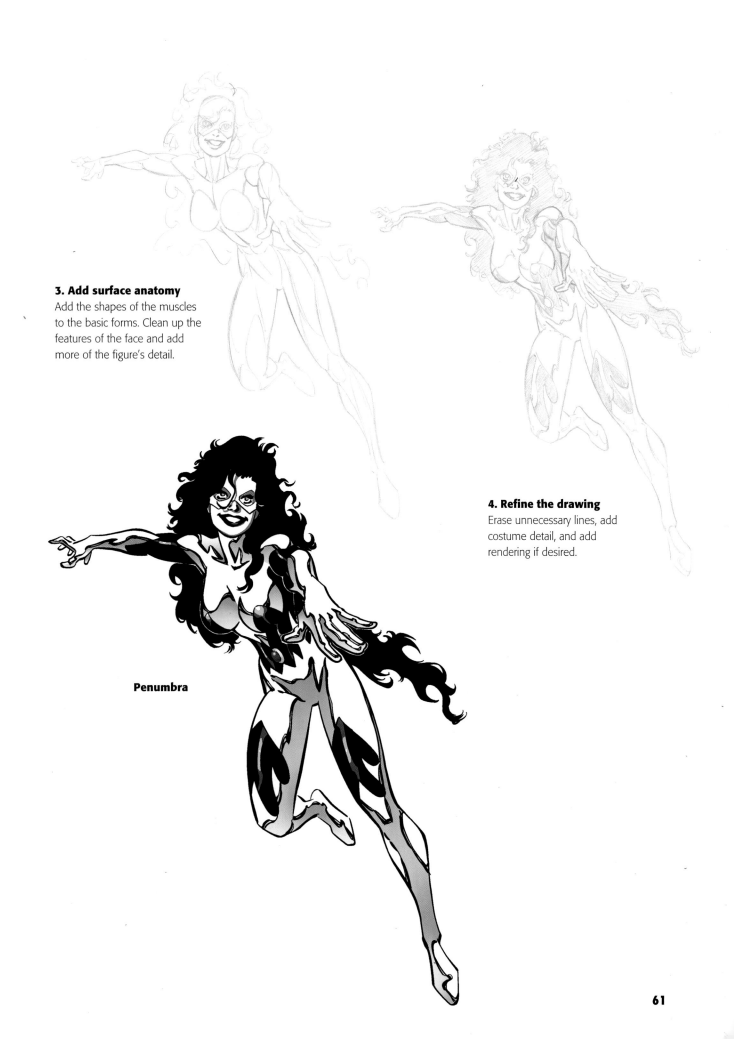

3. Add surface anatomy
Add the shapes of the muscles to the basic forms. Clean up the features of the face and add more of the figure's detail.

4. Refine the drawing
Erase unnecessary lines, add costume detail, and add rendering if desired.

Penumbra

Apollo

Okay, let's practice some more. This time we'll draw a shot of Apollo.
The steps are the same as for the previous drawing.

1. Draw the gesture
Start with the line of action and a
quick gesture drawing to get the
pose down.

2. Build the mannequin
Block in the basic forms of the figure.

3. Add surface anatomy
Lay muscles on top of the form.

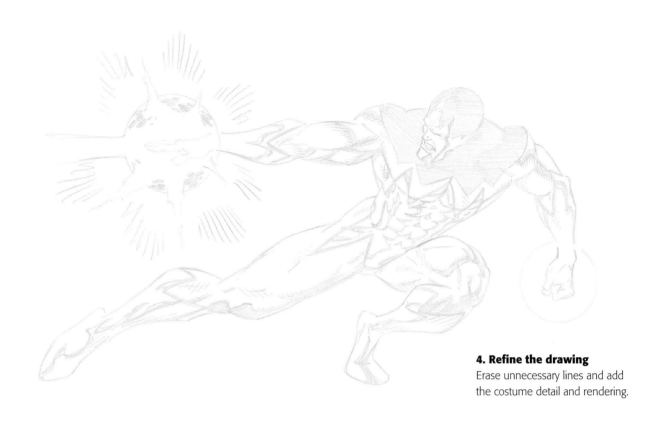

4. Refine the drawing
Erase unnecessary lines and add the costume detail and rendering.

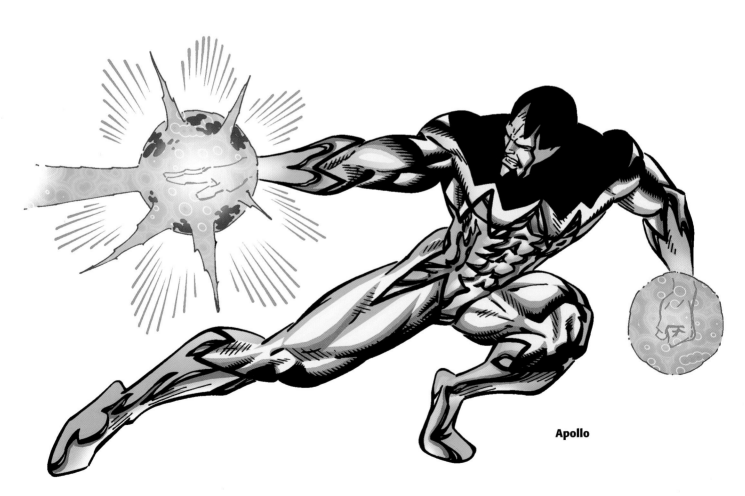

Apollo

Monarch

Now for Monarch, a big, bad dude! The same steps apply as for Apollo, but because Monarch's figure is wider and more massive then Apollo's, I drew his basic underlying forms larger. Study the steps and then copy them to draw the figure yourself.

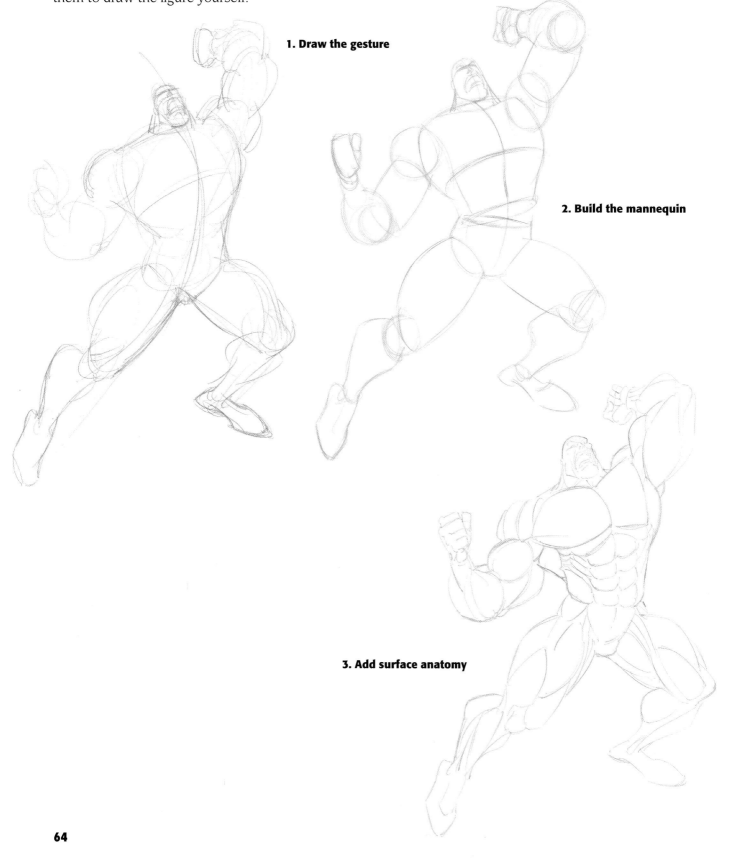

1. Draw the gesture

2. Build the mannequin

3. Add surface anatomy

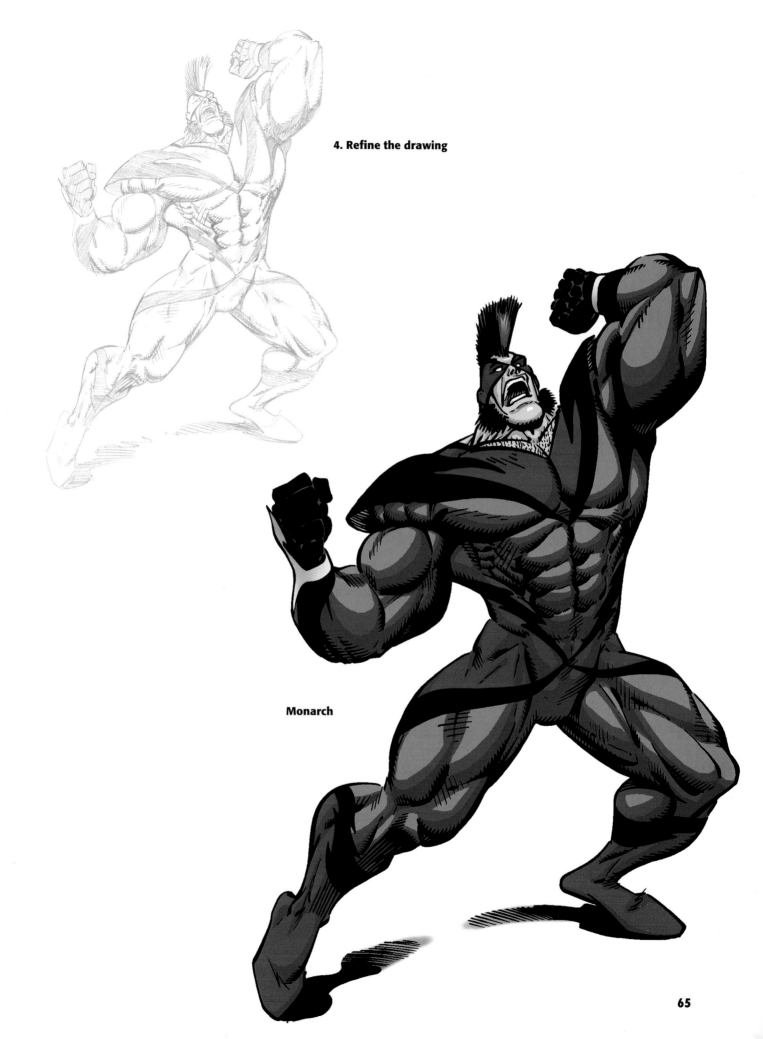

4. Refine the drawing

Monarch

Blubberboy

Now it's time to draw a really different figure type. Blubberboy, like his name says, is a round, chubby guy. If you remember the four basic steps you've learned, drawing a character like this will be a piece of cake. Start with the gesture, keeping in mind that this guy is fat. Then add the basic forms, modified to fit the figure. Apply the muscle shapes, erase unnecessary lines, and add costume details and rendering.

2. Build the mannequin

1. Draw the gesture

3. Add surface anatomy

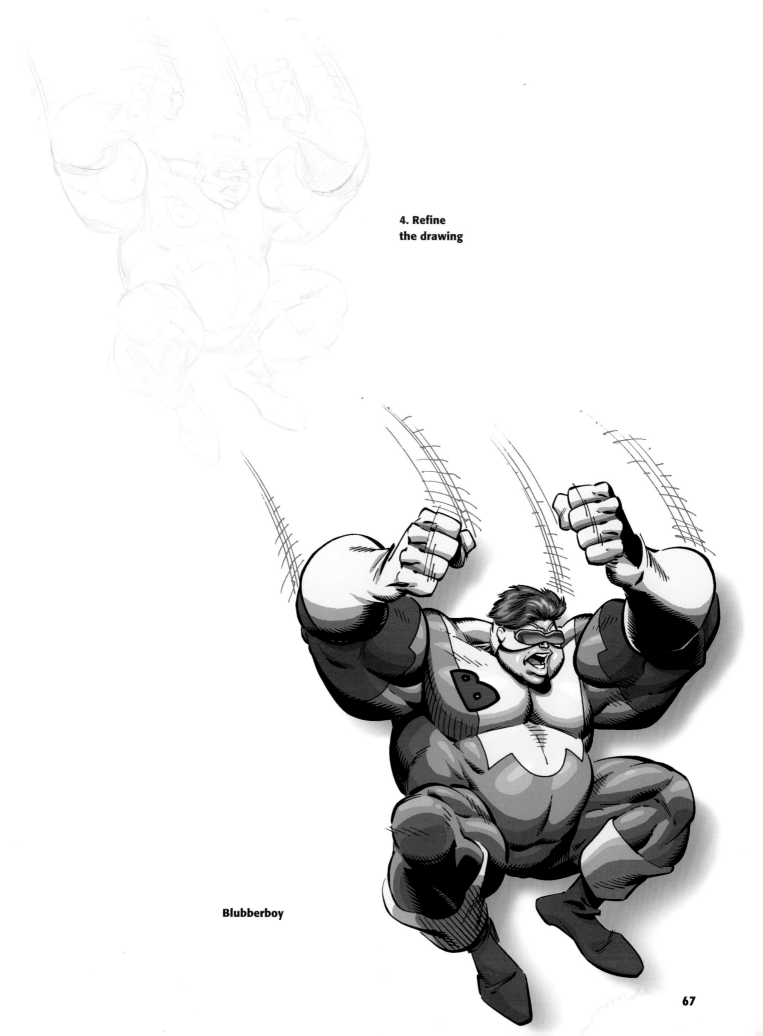

**4. Refine
the drawing**

Blubberboy

Stick

Where would Blubberboy be without his prancing partner Stick? Here is yet another different body type. Like his name implies, Stick is a rail of a man—and I mean skinny! Start with the loose gesture, keeping in mind his thin form. Then add the basic forms of the figure, slap the muscles on top, and finish up as already described.

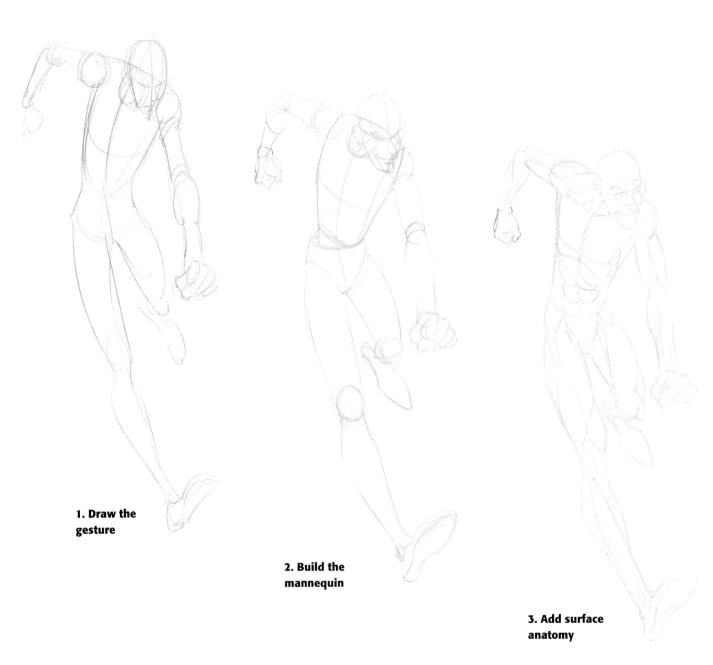

1. Draw the gesture

2. Build the mannequin

3. Add surface anatomy

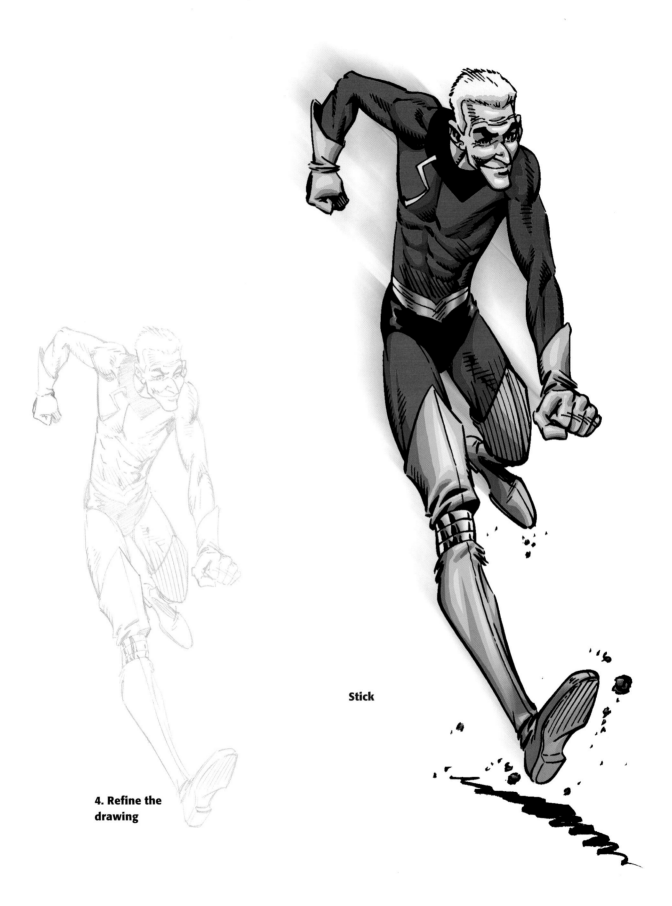

4. Refine the drawing

Stick

Chapter 4
DRAWING THE HEAD

Many aspiring artists put all their focus into drawing powerful bodies, never learning to draw and construct proper heads. In fact, it's not uncommon for me to see portfolios full of finely constructed figures ruined by awkward, unnatural-looking heads. Drawing the head might seem like a hard task, but it's really not. Once you learn the few steps that follow, it will be as easy as riding a bike.

THE FRONT VIEW

The two step-by-steps that follow show you how to draw frontal views of "average" male and female heads.

The Male Head

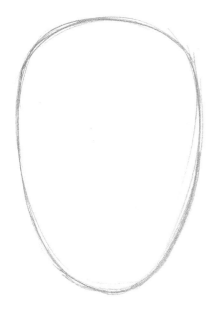 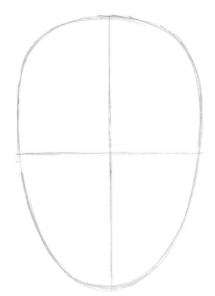 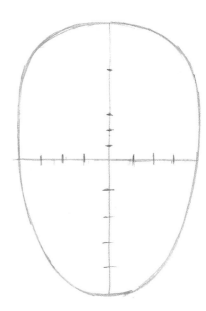

Step 1

First, draw an egg shape. Don't worry if your "egg" isn't perfect or doesn't look like mine; just try to come as close as possible. You can even trace the shape I drew.

Step 2

Divide the shape in half, both vertically and horizontally. If necessary, use a ruler to find the middle of the egg shape. (Even I still use a ruler sometimes.) Use a straightedge if you want to make sure your lines are straight.

Step 3

Time to figure out where the features go. The horizontal line you drew in Step 2 is the eye line. Divide this line into eight equal parts.

Now it's time to divide the vertical line from Step 2. First, use a ruler to divide the bottom half into five equal sections. Then divide the top half of the line into thirds. Take the bottommost of these three sections (the one right above the eye line) and divide it into three more sections.

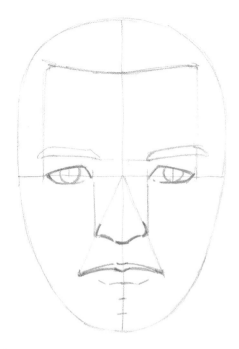

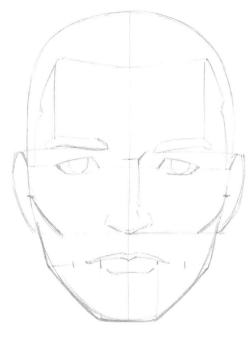

Step 4

Let's draw some features to make this egg look like a head. First, the eyes. Use the lines you marked off in Step 3 for the outside corners of the eyes. The center marks can then be used to draw the irises. (For now, just copy the shapes I drew.) The second mark down from the eye line is where the bottom of the nose will go. To find the width of the nose (where the nostrils will go), drop straight lines down from the inside corners of the eyes.

The next line down indicates the center of the mouth. To find where the bottom of the lower lip falls, simply divide the mouth line and the mark right below it in half. The width of the mouth is found by drawing lines from the middle of the eye line through each nostril to the mouth line, forming a triangle as shown.

Place the eyebrows on the line directly above the eye line. Lastly, use the top mark on the vertical line to draw the hairline. Use the outside corners of the eyes to find the width of the hairline.

Step 5

Okay, onto the ears. Lines drawn across the eyebrows and the bottom of the nose will indicate the tops and bottoms of the ears. As for the bridge of the nose, use the halfway point between the eye line and the brow line. The width of the chin is found by dividing the mouth line into six equal parts, then dropping lines down from the sections on either side of the centerline. To draw the jawline you basically connect the dots: from the bottom of each ear to the mouth line, then down to the width of the chin. (The jawline should then be softened a bit, as shown here.) Cheekbones will start halfway down the ears and curve down to the nose line, as shown.

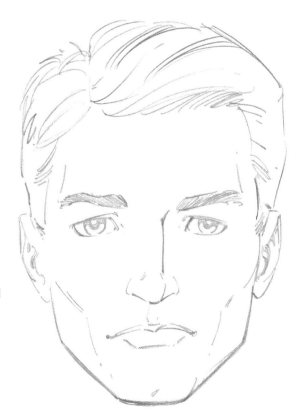

Step 6

By erasing the construction lines and adding hair and other details, we have a pretty handsome dude! Remember, don't get frustrated if your drawing doesn't look like mine. Keep drawing and practicing and soon you'll be making up heads of your own.

The Female Head

Drawing a woman's head isn't much different from drawing a man's. The main differences are that the features should be softer and lines smoother to help create an attractive woman.

Start by following steps 1, 2, and 3 on page 71. You should end up with an egg shape divided in half vertically and horizontally and marked for the features.

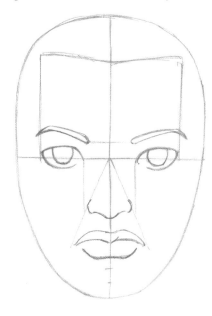

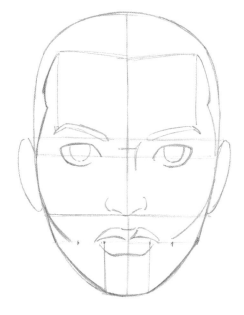

Step 4
Women's features are placed just as on a man, but are drawn a little differently. The eyes are more open and a little bigger, the nostrils should be rounder and softer, and the lips fuller. Eyebrows can vary in thickness and shape, but I keep them thin. I also angle them up more toward the outside of the head.

Step 5
Place the ears and the bridge of the nose as you would for a man. Find the width of the chin as before, too, but keep the jawline smoother, with a more rounded line. Cheekbones start halfway down the ears and run down to the mouth line, as shown, with a nice, subtle curve. Keep it soft.

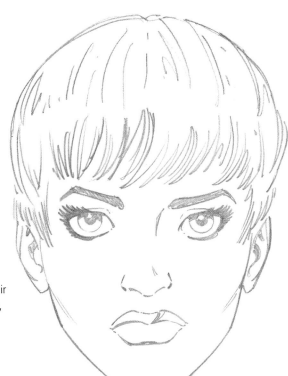

Step 6
Bingo! She's done. By adding hair (I prefer short) and other details, we have an attractive woman.

THE PROFILE

Not everyone in comics is drawn straight on, and that's where the side view, or profile, comes into play. Once you know the rules for drawing front views, profiles are easy!

The Male Profile

Once again, start by following steps 1, 2, and 3 on page 71. You should end up with an egg shape divided in half vertically and horizontally and marked for the features.

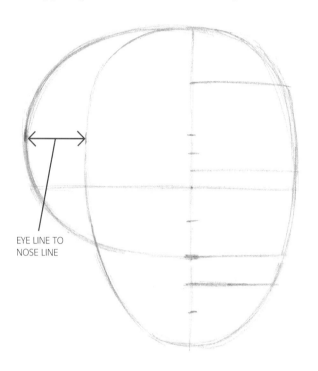

EYE LINE TO NOSE LINE

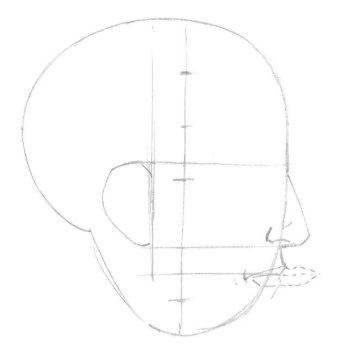

Step 4

Now for the new stuff. Measure the distance between the eye line and the nose line and add this same distance to the left side of the egg shape right above the eye line, as shown. This will establish the back of the head. Now draw an arced line from the centerline at the top of the egg through the mark you just made, then sweeping down to the nose line. This line will give you the basic profile shape. Extend the eye line all the way across the shape to the back of the head. Then extend the hairline, brow line, nose line, and mouth line to the "front" of the egg shape, as shown.

Step 5

Time to add the features. First, divide the new shape in half vertically to find the line the ear falls on. Just as in the front view, the top of the ear should fall along the brow line and the bottom along the nose line. Then sketch in the ear shape.

The bridge of the nose should fall halfway between the brow and eye lines. Then extend the nose down to the nose line, angling it away from the egg shape. (This angle will vary slightly, depending on the person.) Connect the bottom of the nose to the nose line, as shown.

From the bottom of the nose, draw a soft "v" to form the upper lip. The lower lip should extend halfway down between the mouth and chin lines. Extend the lips to show the side of the mouth, which should be half as long as a mouth in the front view (shown here with dotted lines).

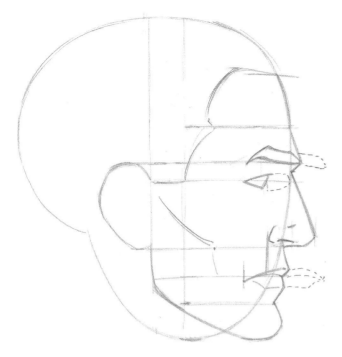

Step 6

Remember that mark you made toward the bottom of the face? That's the chin line. From the bottom lip draw a line that angles back just slightly to the chin line, then angle it back out and around, forming the chin. For the jawline, first extend the mouth line to the ear line. Then draw a line from the bottom of the ear to the mouth line and connect that to the chin.

For the eye, simply draw a front-view eye on the eye line, starting at the edge of the shape (shown here with a dotted line). Then cut the eye in half; the inner half will form the eye in profile. The eyebrow falls on the brow line and is half the length of a front-view eyebrow (again, shown with a dotted line). To mark the nostrils, divide the mouth in half and draw a line straight up to the nose line. The cheekbone swings down from the ear to the nose line, just as in a front view. The hairline is drawn as indicated, depending on the amount of hair the character has.

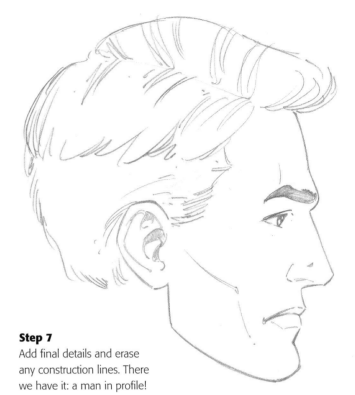

Step 7

Add final details and erase any construction lines. There we have it: a man in profile!

A profile view of Apollo from *First Man*.

The Female Profile

Follow steps 1, 2, and 3 on page 71. You should end up with an egg shape divided in half vertically and horizontally and marked for the features.

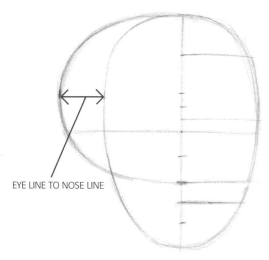

EYE LINE TO NOSE LINE

Step 4

Just as you did for the male profile, measure the distance between the eye line and the nose line and add this same distance to the left side of the egg shape right above the eye line. Then draw an arced line from the centerline at the top of the egg through the mark you just made, sweeping down to the nose line. Extend the eye line all the way across the shape to the back of the head. Then extend the hairline, brow line, nose line, and mouth line to the "front" of the egg shape.

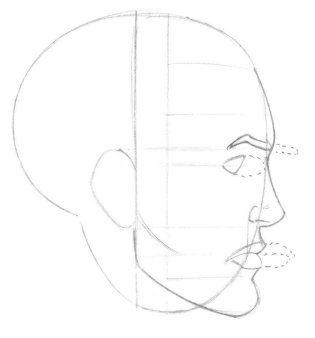

Step 5

Place the features as you would for a male (see pages 74–75), but keep in mind what I said earlier about the differences between male and female features. Women's eyes are usually open wider, their mouths are fuller, and their eyebrows thinner. When drawing a female nose in profile, draw more of a slope then the harder angle on a man. Women's cheekbones slope down to the mouth line, not the nose line. And the jaw line should be softer and less angled.

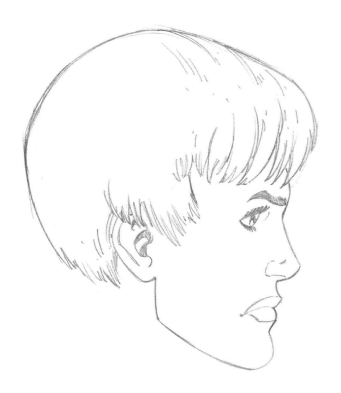

Step 6

Add hair, erase the construction lines, and we have a woman in profile. Note that you don't always need to leave the cheekbones in the finished drawing.

THE THREE-QUARTER VIEW

Most comic book faces are actually drawn from a three-quarter view, with the head turned partially away. Using the rules you've already learned, drawing this view will be easy.

Start by following steps 1, 2, and 3 on page 71, giving you an oval marked off for features as for a front view.

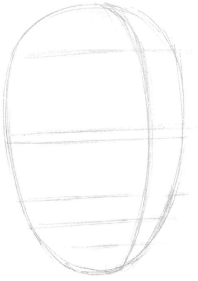

Step 4

Use a ruler to extend the marks on your vertical line across the oval. Then gently erase your vertical centerline and redraw it according to how much you want the head to turn.

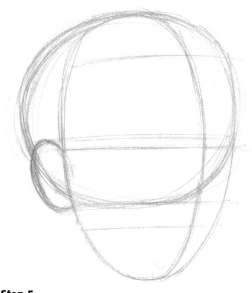

Step 5

Draw a rough sphere in the top portion of your oval, with the bottom of the sphere falling on the nose line. This sphere now indicates the skull. Use the measurements on page 72 to place the ear; here it falls on the outside of the oval.

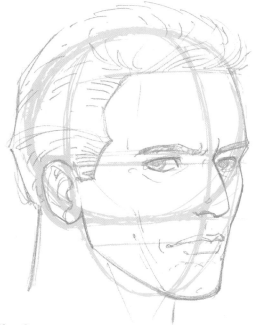

Step 6

Draw the features on their appropriate marks.

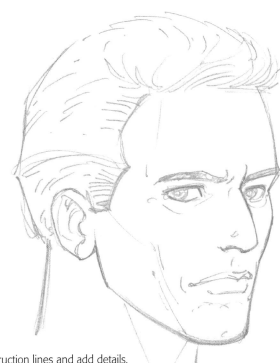

Step 7

Erase the construction lines and add details. Follow the same steps for a female, adjusting the features as previously learned.

DRAWING THE FEATURES

The features of the face are very expressive. By making even a slight change, such as turning the corner of the mouth up a little, you can dramatically alter a character's expression. As with everything else in this book, the features are constructed using the three basic forms.

Eyes

Everything starts with a basic form. The eye is a ball, or sphere. Of course you don't see the whole ball when drawing the eye, but knowing what the shape is will help you draw it and give it form.

The eye is a ball, or sphere.

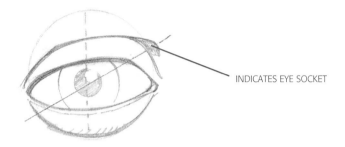

INDICATES EYE SOCKET

This is a simple front view of a right eye. Notice how the eyelids have been drawn. The upper lid angles up and is higher toward the center of the face. The bottom lid angles down slightly on the outside of the eye. Normally you can see a slight indication of the eye socket above the upper lid; this is not a shadow, but the actual bony outline of the eye socket.

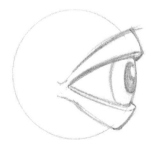

Here is a side view. As you can see, the upper and lower lids have depth and actually rest on top of the eyeball.

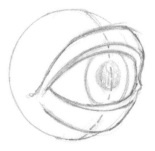

Here is a three-quarter view. You can still see some of the inner eye where the upper and lower lids wrap around and connect. When drawing the eye from various views it may be helpful to draw the centerline of the eyeball (shown here with a dotted line) to help you draw the lids properly. And of course the pupil can be placed anywhere within the eye, depending on where your character is looking.

Noses

The nose is roughly a triangle shape flattened off at the top (the bridge of the nose). Most people's noses angle up at the bottom, forming another, smaller triangle shape. Using these basic forms will help you draw any type nose you can imagine from any angle.

This is a front view of a nose. Notice the flattened triangle shape. I've included a finished drawing of a nose as well for comparison.

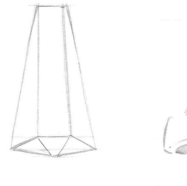

Here is a side view. Notice the smaller triangle formed at the bottom of the nose. If you compare this to the finished drawing, you can see that this smaller triangle is where the nostril opening falls. Notice how the nostril angles back slightly, just as in the basic triangle shape.

Lastly, a three-quarter view. Notice in the more realistic drawing how the outer nostril is hidden from us.

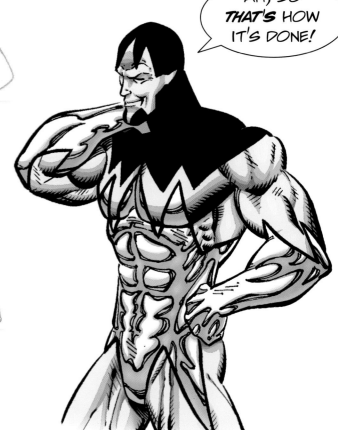

AH, SO *THAT'S* HOW IT'S DONE!

Lips

The lips are also constructed of basic forms: flattened spheres. All the spheres are the same size—except on a man, when the top spheres are flatter. Thinking of lips this way will help you give them form and volume. The examples shown here are of a woman's lips; on a man, the upper lip would be thinner.

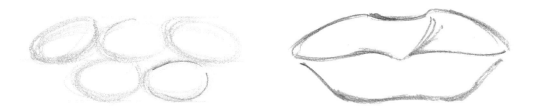

For a frontal view, three spheres make up the top lip and two make up the bottom.

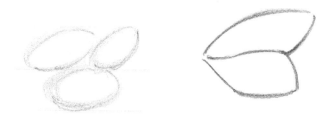

To draw lips in profile, just draw half of a front-view mouth. The leftmost top and bottom spheres should be left as is, with the center sphere cut in half.

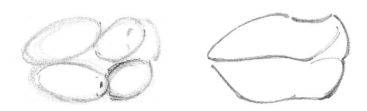

The three-quarter view is a tough one because you need to show how the lips recede as they turn away from the viewer. This is done by overlapping the spheres, as shown. (Notice the dotted lines showing where the spheres have been "drawn through.") Once the lips are finished and the construction lines erased, the lips will appear to recede.

Ears

Though the ear looks complex, it too is based on a simple basic form: the oval.

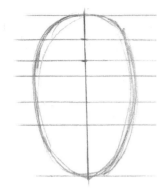

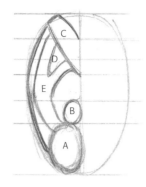

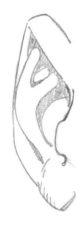

For a front view of the ear, divide an oval in half vertically. Then divide the vertical line into thirds. Divide the top third again, into thirds, and divide the middle third in half.

If you are drawing a right ear, use the left half of the oval (and vice versa for a left ear). First, sketch an oval shape in the bottom third section (A). Draw another oval shape in the bottom half of the middle section (B). From the very top line, draw a line up and out to the edge of the oval (C). Do the same from the third mark down (D). The inside of the ear is a "Y" shape (E).

Notice how the ear takes shape in the finished drawing here (and those that follow) by adding simple shadows and erasing the construction lines.

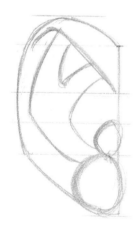

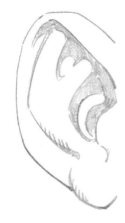

Follow the same steps to draw an ear in profile. The shapes are wider and flatter than in a front view, but all the divisions are the same.

The ear in a three-quarter view is somewhere in between a front and side view: wider than the first, not as wide as the second. Again, notice that all the divisions remain the same.

For the back of the ear, simply draw the shape of the front view and then add the simple details that make up the back: the outer ridge, which is a thin shape, and the rounded bowl shape where the ear attaches to the head. (In most cases, the back of ear is covered with hair anyway.)

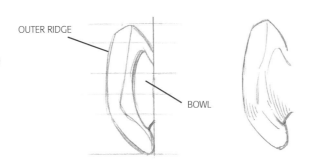

OUTER RIDGE

BOWL

CREATING DIFFERENT FACES

By taking the basics you've already learned and making simple modifications to the features, you can create a variety of different characters. All of the men below and opposite, for example, were drawn using the same exact head shape.

Play around and have fun when coming up with different character types. Applied the right way, the rules taught earlier will serve as a sort of toolbox for creating any character you want!

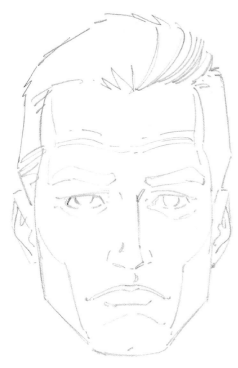

This pretty typical guy was drawn using the steps on pages 71–72.

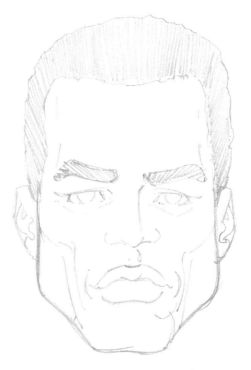

By taking the same head shape and changing the features, you can create a totally different look. For this character, I shortened and widened the nose a bit, giving me room to play with the mouth area. I also pulled the cheekbones up and added more creases next to them. The more the cheekbones are indicated, the older the person usually looks.

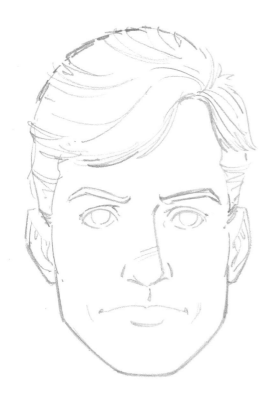

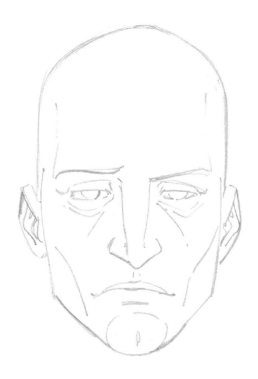

Going for a younger-looking man is as simple as not drawing any cheekbones at all, opening the eyes and making them rounder, and drawing a softer, less angled jawline. Different hairstyles will also help establish age and add character to your drawings.

Now for the "bad dude." Actually, I created the feeling that this guy was up to no good by simply giving him a bald head and squinting his eyes a bit. Notice also how I widened the bridge of his nose and really tapered it toward the bottom. A rounder chin and cheekbones that slope steeply downward make his face look thinner, even though his head shape is the same as in the other drawings.

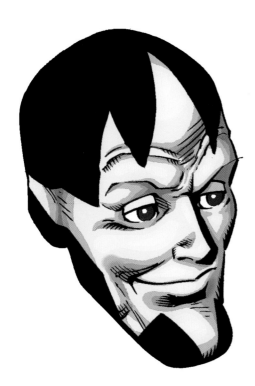

AND NOW YOU KNOW HOW TO GET A HEAD!

Of course, not everyone's head is the same shape. Some people's heads are longer, some wider. Simply sketch the shape you want to work with. You can also start with the basic oval shape as a guide, then superimpose the shape you want to work with on the oval. You can then feel free to play with the features and how you place them.

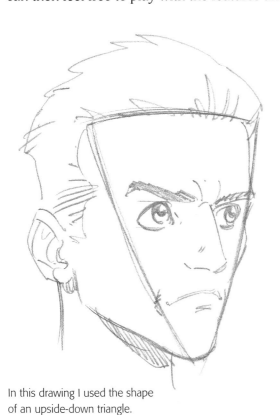

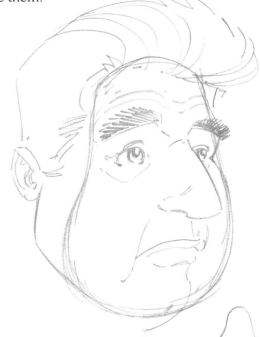

In this drawing I used the shape of an upside-down triangle.

Here I started with a sort of pear shape. This gives the character a fuller, fleshier face. Drawing smaller eyes and ears also gives a larger overall feeling to the character, without the viewer even seeing the rest of his body. Finally, I pulled his hairline closer to his brow to help emphasize the lower part of his head.

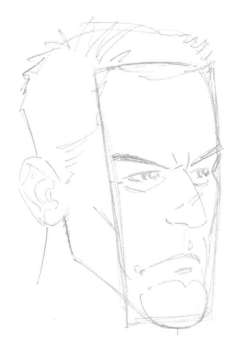

Using a rectangle for the head shape will give your character a thinner look. I also moved this man's eyes in closer together and gave them a squinty, shifty feel. Since I started with a long, tall shape it made sense to give the character a larger forehead and defined cheekbones to emphasize his thinness.

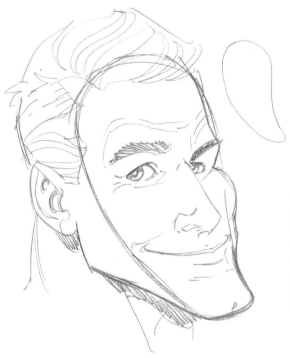

This silly-looking fellow's head shape was modeled after yours truly . . . well, except for the neck. If you take notice of the different profiles people have, you'll see that some people's heads slope more than others. On this character, for instance, the chin is more pronounced and slopes outward. This character also has thinner lips and larger nostrils, which help give him a distinct personality.

Women's head shapes vary just as much as men's. It's fun to try experimenting with different head shapes while still trying to retain the attractiveness of your female characters.

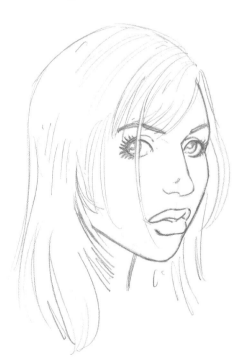

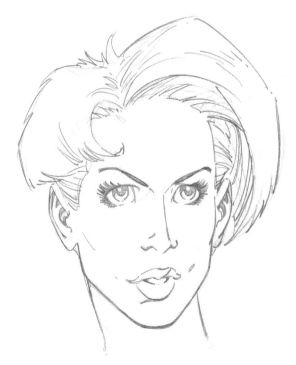

This woman's face has a nice roundness that's carried through all of her features. Her eyes are rounder and more open than the standard female, her lips are fuller, and even her nose is rounder at its base. She has a soft jawline and no cheekbone indications.

This woman has a certain edge to her, a kind of toughness. I established this with a longer, narrower head shape, a more angled jawline, and just a hint of cheekbones. I also made her nose straighter and angled up her nostrils and brow, too. Once you establish a certain overall look for a person, such as the narrowness of this woman, it's important to maintain those aspects throughout the entire head and face.

Here I was going for a wider look. I brought down the hairline and drew the chin a little wider than normal. The thicker eyebrows and wider nose also contribute to this woman's "look," giving her a nice individuality while retaining her attractiveness.

For this drawing I wanted to show that not all women need to have the typical nose to be attractive. Notice how I curved this woman's nose out slightly (versus curving it in, as is more usual). Her outer cheek is also more defined, but still retains that nice fluid line women should have. Little details like the addition of a dimple can make a big difference when trying to come up with faces that aren't all alike.

Lastly, I wanted to show a drawing that is very exaggerated but still cute. All I did here was enlarge this woman's eyes, draw her ears a tad smaller, and give her a thinner neck. Even these little modifications give the character a more youthful, innocent look.

SHOWING AGE

As people grow older, certain changes occur to their faces and heads: The skin sags, the hairline recedes, wrinkles start occurring around the eyes, jaw, and cheekbones. When used in drawing, these types of indicators will help convey different ages for your characters.

Once you're comfortable with the step-by-steps that follow, trace other characters in this book and try using the same steps to make them look older.

Age for Men

Let's start with a man in his thirties and trace the changes in his face over the next forty years.

This man is thirty to thirty-five years old, an age established by the indications of cheekbones and a harder jawline.

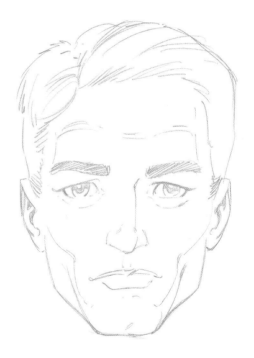

Ten years or so later, this same man is now in his forties. His cheekbones are more pronounced, with creases next to them where the skin has loosened. The wrinkles in his forehead are more prominent and small bags have started to form under his eyes. Overall, though, there is not much difference between this and the previous drawing.

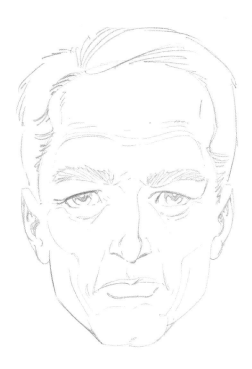

The same man is now in his fifties. Notice how the skin seems to sag more around his jawline. His cheekbones are more prominent as the skin withdraws inward. The eyebrows are a little bushier and more wrinkles and bags have formed under his eyes. The tip of his nose is a little more pronounced, his hairline has started receding, and more wrinkles crease his forehead.

Twenty years or so ahead is the same man, now in his seventies. The hairline is really receding and we can see indications of the top of his forehead. His jawline is no longer recognizable and his flesh appears to just hang down onto his neck. The cheekbones are very pronounced and his nose has a bonier look. Crow's-feet appear heavily around his eyes and the bags are more evident. These old guys also have really bushy eyebrows.

Age for Women

Most women (unless they're movie stars) will age the same way. Let's follow a woman from her thirties to her seventies.

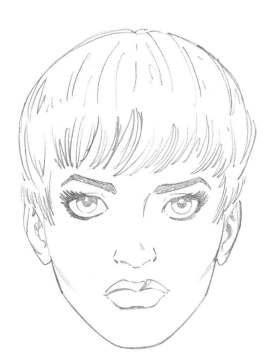

This woman is in her late twenties, early thirties. She's an attractive, full-faced woman.

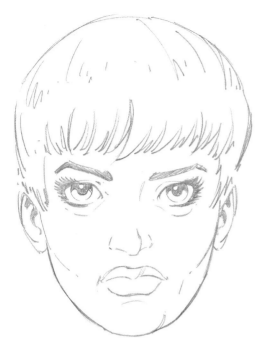

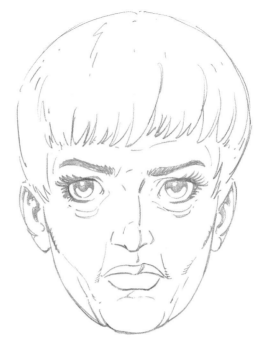

We tack on twenty years and the same woman is now in her forties. Her jawline has rounded out, starting to sag. Her cheekbones are a little more prominent, though not as much as on a man. Her chin has started to round up and show more. And those dreaded wrinkles under her eyes have begun showing, too.

Fast forward another twenty years and she's now in her sixties. Just as on a man, the skin around her jawline is sagging, though her face still shows a nice roundness. Wrinkles have begun to set in around her chin and cheekbones, and we can see a hint of wrinkles across her forehead. The bags under the eyes are also more evident.

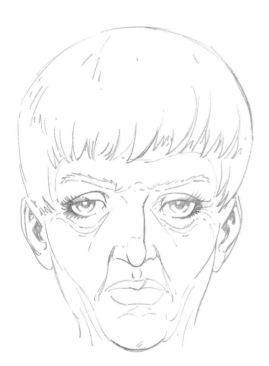

Our woman is now in her seventies. Her jawline has disappeared and the skin just flows down into her neck. Notice how all the lines flow smoothly to create a nice fluidity to the face. Her eyelids drop down and the crow's-feet appear. The muscles around her nose have started to droop and appear around her mouth. Her eyebrows are a little bushier, although not nearly as much as a man's, and her nose is more pronounced. Remember, the hairstyle on a woman would normally change several times over such a long period. I kept this woman's look consistent so the drawings would be easier to compare.

Chapter 5
USING REFERENCE MATERIALS

When I was a kid, I thought everything in comics was drawn from the artist's imagination. Oh, how I was wrong. To draw cars, you should look at cars. To draw buildings, you should look at buildings. Sure the artist will create things like futuristic guns, spaceships, and so on, but all the everyday objects should be drawn from their real-life counterparts. *Reference* refers to any object or material that you look at to help you draw.

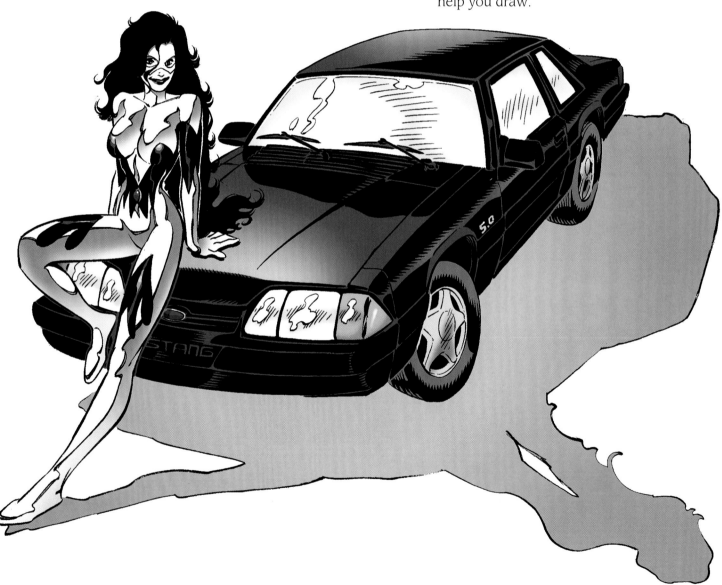

PROPS AND POSES

In comics you can be asked to draw anybody doing anything, and if you don't know what the pose or object looks like, you'd better find a picture of it so you can draw it accurately. I have all sorts of reference material by my desk: books on guns, cars, sports, and bodybuilding, clothing catalogs, and much more. And what do you do if you are asked to draw something and you can't find a picture of it? Simple: Create your reference by snapping a few photos of your own.

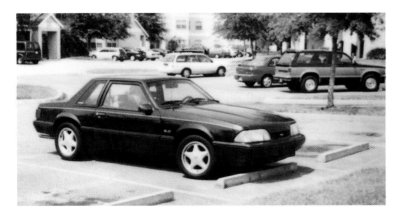

To draw the car on page 90, I first took this photo of my car, then drew it from a different perspective using the rules in Chapter 1.

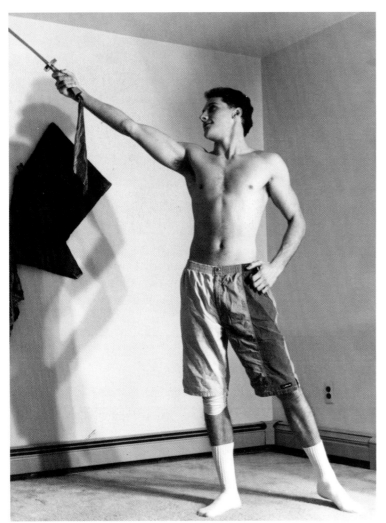

This photo of yours truly, from college, was taken specifically for the drawing on the next page. I sometimes photo reference a certain pose to make sure I draw the weight distribution correctly.

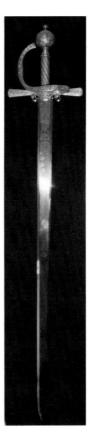

I also used this picture of a sword, as well as a close-up of the sword's handle, to help me draw the barbarian's sword realistically.

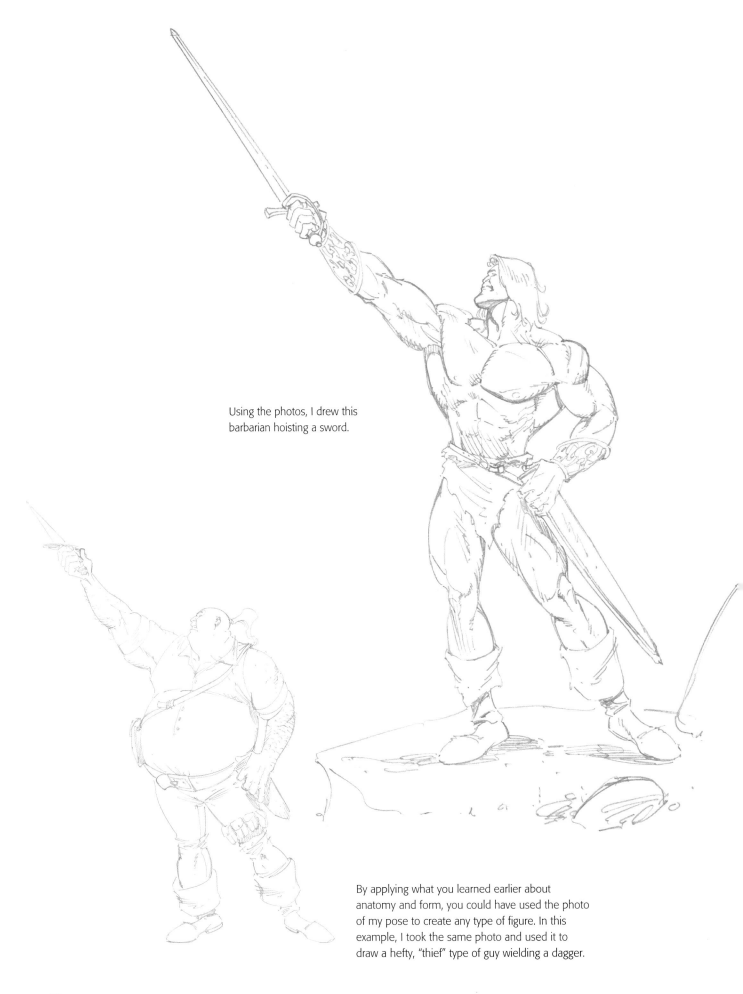

Using the photos, I drew this barbarian hoisting a sword.

By applying what you learned earlier about anatomy and form, you could have used the photo of my pose to create any type of figure. In this example, I took the same photo and used it to draw a hefty, "thief" type of guy wielding a dagger.

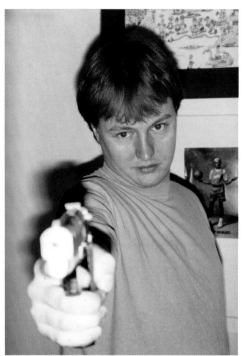

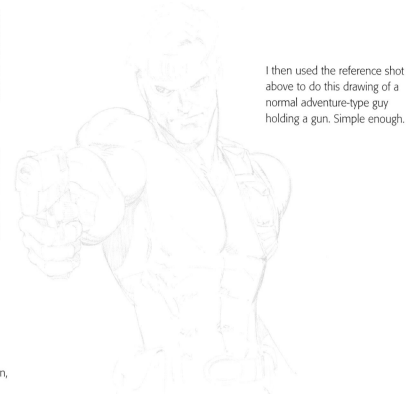

I then used the reference shot above to do this drawing of a normal adventure-type guy holding a gun. Simple enough.

I needed a reference photo of a man holding a gun, so I simply posed a friend of mine with a toy gun and snapped a few shots.

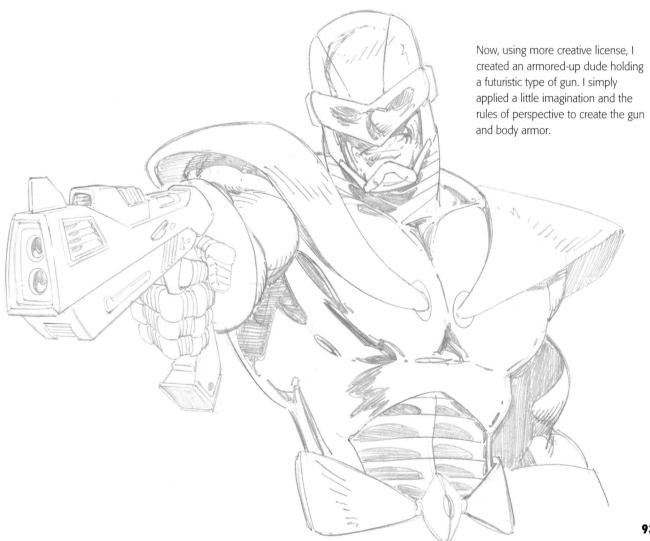

Now, using more creative license, I created an armored-up dude holding a futuristic type of gun. I simply applied a little imagination and the rules of perspective to create the gun and body armor.

LIGHTING

Many beginning artists find it difficult to create believable lighting. It might be helpful to take pictures of someone under various types of light sources (a strong fluorescent light, candlelight, diffuse outdoor light, and so on) and with the light coming from various directions. Then you can simply use the relevant photos as reference when applying lighting to your drawings.

Once again, the guy in the photo is me, this time with a strong light source on my right side and a weaker source on my left. I then applied this same lighting to two of the heads I'd drawn earlier (shown below).

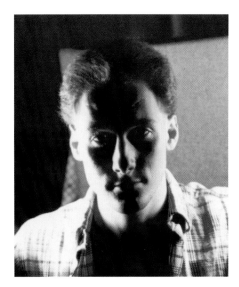

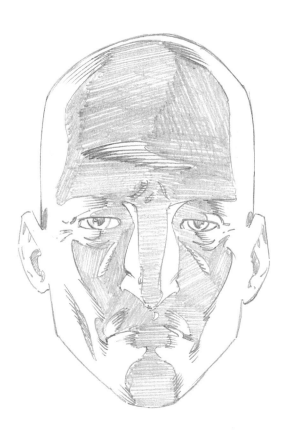

In this photo there are two strong light sources, one on either side of my face. Notice how I was then able to adapt the lighting to the character's face at right. Lighting is a great tool when used properly.

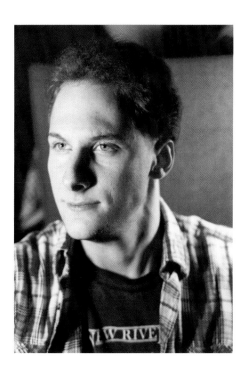

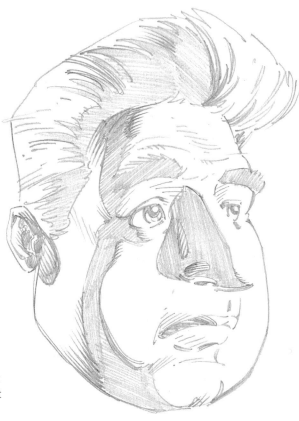

One last photo of me, this time with one light source slightly in front and to the side of my face and the other behind my head. Although I applied the same lighting to the character shown here, notice how the light wraps a bit differently on his fuller cheeks. Always remember to adjust the lighting to fit the particular character you are drawing.

BACKGROUNDS

Anything around you can be photographed to inspire backgrounds for your scenes. If a photo doesn't show the scene from the angle you need, just apply the rules of perspective to draw it from the proper view.

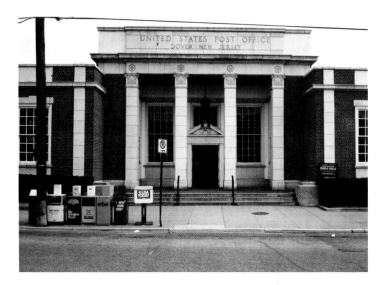

This photo of a post office is pretty boring, straight-on stuff.

Using what you know about perspective, you can twist and turn the photo to draw it from any angle. Here I used three-point perspective to create a drawing that's much more exciting and dramatic than the original photograph.

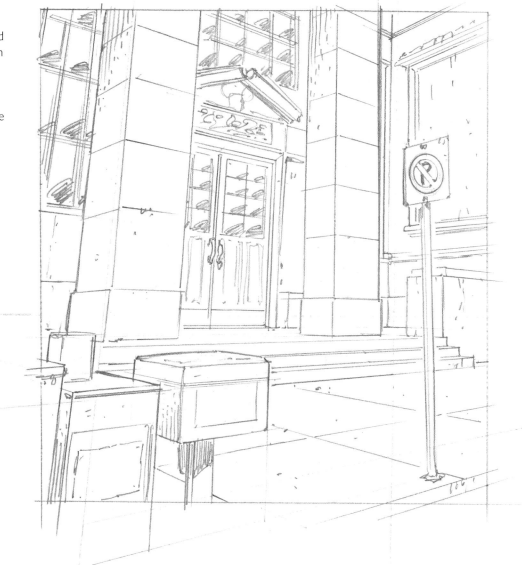

WOMEN

Drawing women is not the easiest task. I've seen many aspiring artists, both male and female, draw women that are very masculine. Partly because of this, lots of artists (including myself) use reference photos when drawing female heroes. Ideally, you should always be able to draw out of your head, but sometimes photo referencing is necessary to help you convey the subtleties of the form. The point isn't to copy the photo exactly, but to use it as a starting point.

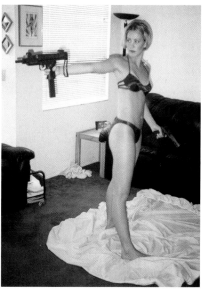

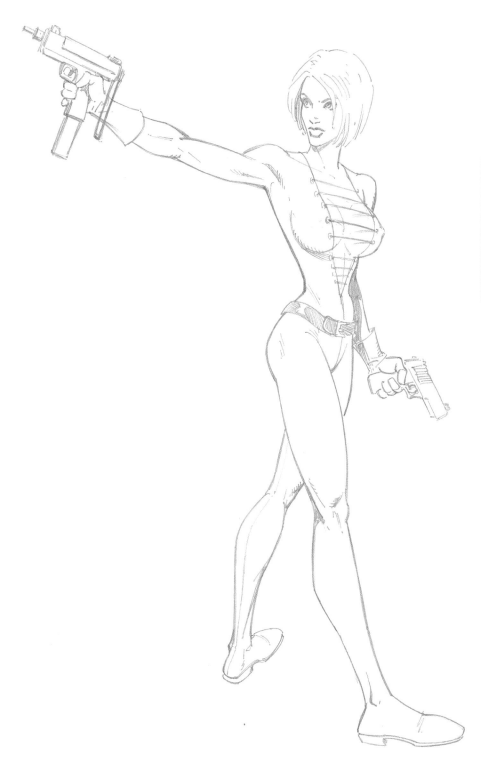

For this example, I first set up a model with a couple plastic toy guns. I then turned the model into one dangerous-looking adventure heroine (at left). Notice how I thinned up the waist, drew her pointing arm higher, and spread her legs a bit further apart.

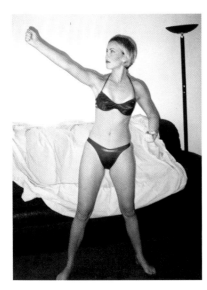

Here I needed reference for a female hero holding up a bad guy. Obviously, I couldn't pose the model holding up a man, so I improvised. I started by taking a photo of the model in the stance I needed, then simply added a bad guy trembling with fear. Notice again the few adjustments I made in the heroine's pose: Her legs are spread further for a firmer stance and her back is more arched.

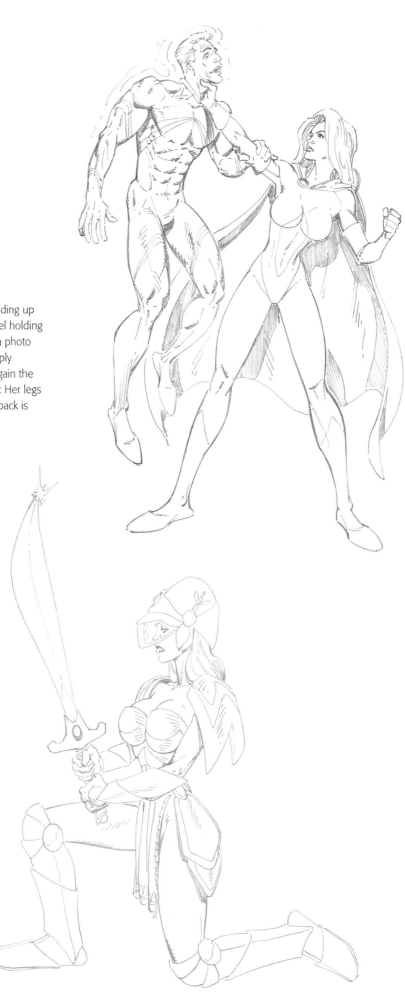

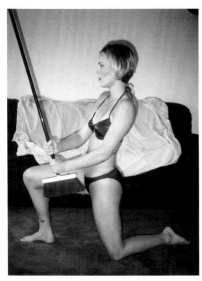

Sure, this model is holding a broomstick, but by using your imagination you can use it to create a female warrior brandishing a sword. Remember, photo reference should not be used as a crutch but as a helpful tool in creating your drawings.

USING MULTIPLE PHOTOS

Sometimes you may have to use parts of several reference photos to put a scene together. When doing this, it is especially important to follow the rules of perspective and proportion from Chapter 1 to maintain uniformity in your drawing.

 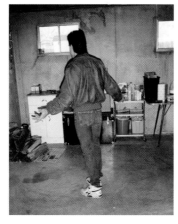 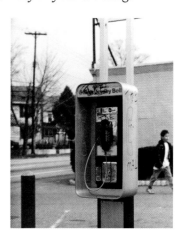

I used three different reference photos for the scene below. A couple pictures of my brother helped establish the characters' poses, and a photo of a pay phone was used for the background. Notice how I added windows to the building behind the pay phone. Never be afraid to supplement or change photos you're using for reference. In this case, I felt that the background needed to be broken up a bit more.

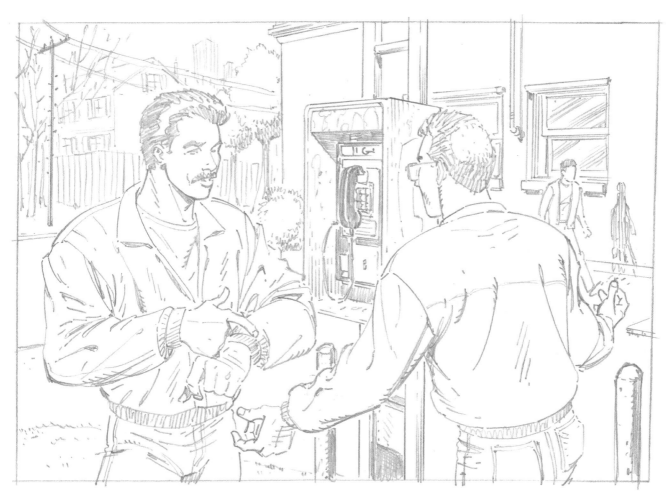

Chapter 6
DRAWING THE PAGE

Now we get to the heart of comic book art: drawing an actual page. The process begins when a writer hands you a script. Then, just as a director would for a movie, you decide how to tell the writer's story. How should the story be broken up into visual images? How should it be paced? What types of shots should you use? Remember, when the printed comic book comes out, no one will see the writer's original script; your work will be all that remains to tell the story.

DESIGN ISSUES

Before we actually walk through the process of drawing a page, let's start with some basic design issues you'll have to settle when planning your panels. Panels can be drawn in many ways, each giving a different feel to the story.

Panel Layout

First, how should you arrange your panels on the page? While panels can be any shape or size and can be organized in any way, I find it best to start with one of the basic layouts below. Then, once I've figure out my shots, I play with the panel layout to make it more dramatic.

The drawings that follow show some of the standard panel layouts used in comics, ranging from a one-panel page (called a "splash" page) to a nine-panel page.

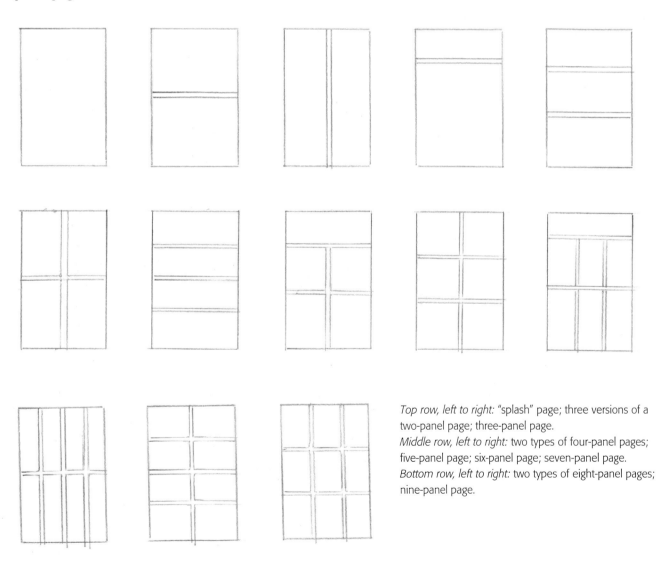

Top row, left to right: "splash" page; three versions of a two-panel page; three-panel page.
Middle row, left to right: two types of four-panel pages; five-panel page; six-panel page; seven-panel page.
Bottom row, left to right: two types of eight-panel pages; nine-panel page.

Camera Angle

When drawing comics, you are the director, just as for a movie. The position of the "camera" for each shot (or panel) is up to you. There are three basic shots in comics: the close-up, the medium shot, and the long shot.

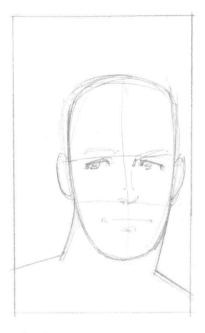

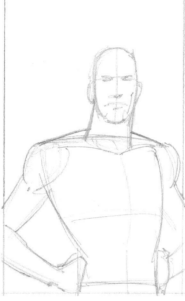

The close-up

This shot is generally used to show a character's reaction, or to focus in on a certain body part or object, like a ringing telephone.

The medium shot

The medium shot is usually used to focus in on a certain character or characters in the scene, showing more of their figures than in the close-up.

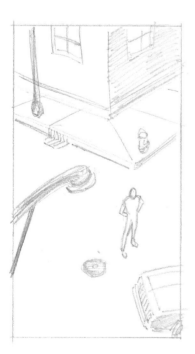

The long shot

The long shot is used to establish the location of a story or scene. In this example, you can see that the main character is standing in the middle of a street.

THAT BLAST WAS SOME KIND OF *SIGNAL*.

A medium shot of Apollo from *First Man*.

Right: Close-up and long shots of Apollo from *First Man*.

Composition

You'll also have to decide how to frame each image in the panel. Your first instinct may be to center the panel's main focal point, but this is exactly what you should *not* do: It's boring, and it won't leave room for the word balloon.

Instead, divide your panel into thirds, both horizontally and vertically, to create nine equal sections. Then use the sections to make sure you avoid placing your panel's focal point in the center section. This will also help you leave room for word balloon placement. A good rule of thumb is that one-third of the panel must be left for the word balloon.

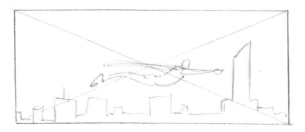

Don't do this!
The panel's focal point should never be centered.

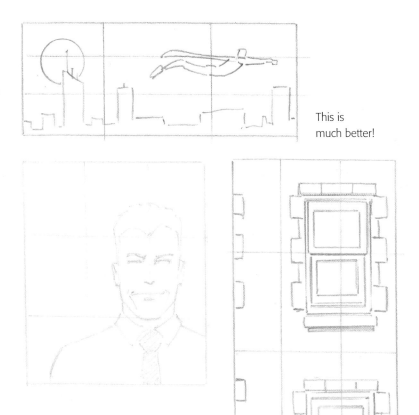

This is
much better!

104

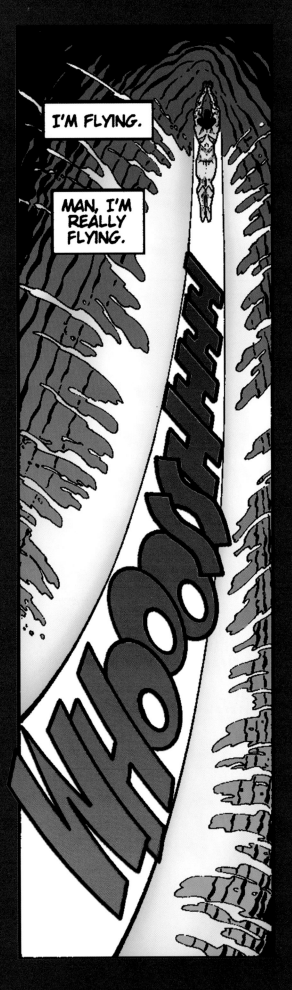

Here's a shot of Apollo from *First Man*. Notice how our hero isn't centered in the panel.

Cropping and Tangents

There are a few basic rules to keep in mind when cropping out extra space around your subject. The pictures below and opposite show some common mistakes and their solutions.

Wrong. Never crop at joints of the body (knees, ankles, elbows, and so on), which can make your figure look awkward. You'll also want to avoid creating tangents, or lines that overlap and therefore disappear. Notice in this example how the background structures align with the character's arms.

Right. The character has now been raised so you can see his left foot, and his right leg is now cropped a bit lower, below his knee. The tangents were eliminated by simply moving the buildings.

Wrong. When drawing a figure flying or jumping, don't crop off parts of the body, as here, but leave plenty of air all around the figure. This example also has some bad tangents. Notice how lines in the building on the right align with the character's shoulder and leg. Also, you can't see the upper-right corner of the building on the left; this is a no-no.

Right. Now you can see all of our hero's limbs, and you really get the sense of him flying. The background buildings were adjusted to get rid of the tangents.

Wrong. It looks as though this guy has a head growing out of his shoulder! Because the woman's chin aligns with the man's shoulder, they seem to merge into one form.

Right. The tangent was eliminated by simply raising the woman a bit higher.

Another shot of Apollo from *First Man*. Notice that we can see his entire figure in space. There are no awkward tangents with the background buildings, and the figure has been placed off-center in the panel.

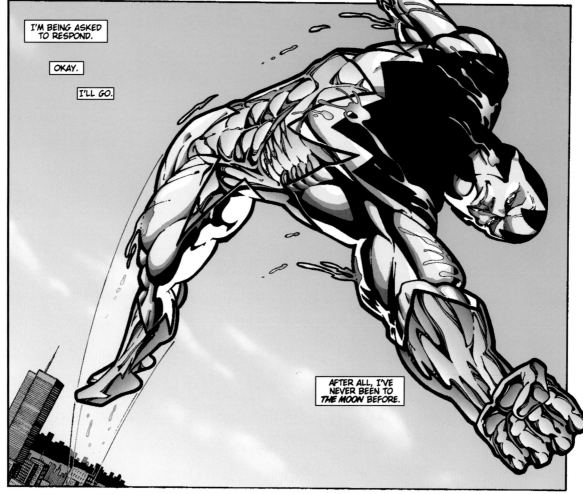

I'M BEING ASKED TO RESPOND.

OKAY.

I'LL GO.

AFTER ALL, I'VE NEVER BEEN TO *THE MOON* BEFORE.

Pacing

Along with the writer, you as the artist have control over the pacing of the story. Suppose the basic story for a page is that the hero flies to his secret hideaway and presses a control panel of some sort to open the door. He then walks into the hideaway. The following are two different ways this story could be paced.

In this example, the story flows rather quickly. The first panel establishes our hero and his hideaway. The second shows the hero pressing the control panel. And the third has him entering the hideaway.

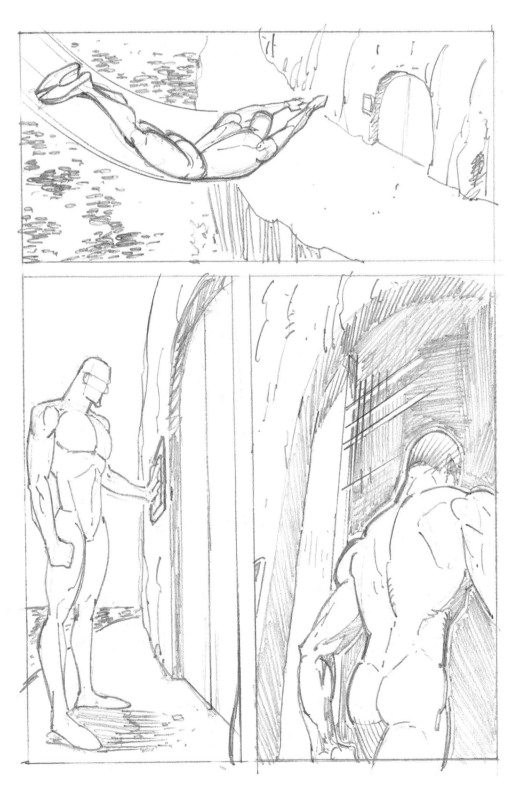

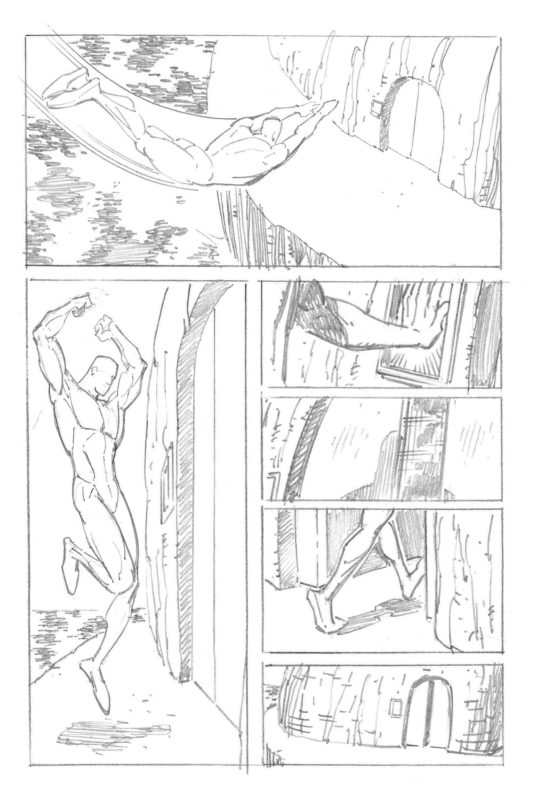

To slow the timing down a bit, just add more panels. Here I've kept the same first panel as it works fine to set up the scene. In the second panel, I show the hero landing. By then giving a close-up of his hand, I add importance to the action of pressing the control panel. The doors slowly open. We know our hero is in front of the doors by the shadow he casts on them. Instead of then showing another shot of our hero from the waist up, I've focused on his legs as he enters. (The page already had good figure shots and didn't need another.) Lastly, I pulled the camera back to show the doors closing behind him.

While both pages work fine, the addition of some panels to the second page makes it read slower, adding importance to what the hero is doing. The first example makes the sequence seem like just an everyday activity.

Flow

It is important to lead the reader's eye from panel to panel on a page. You do this by designing your panels to flow naturally from one to another. Keep in mind that we are taught to read words from left to right, and that this affects the order in which we "read" panels.

I took the same two pages from before, this time adding arrows to show the flow of each page.

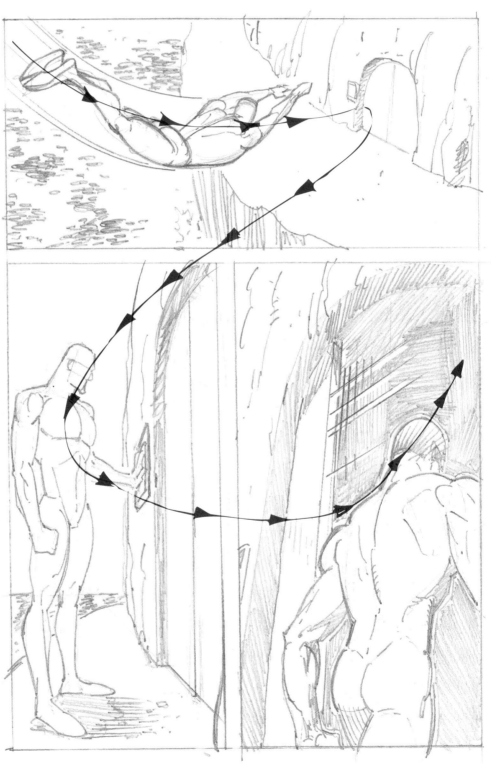

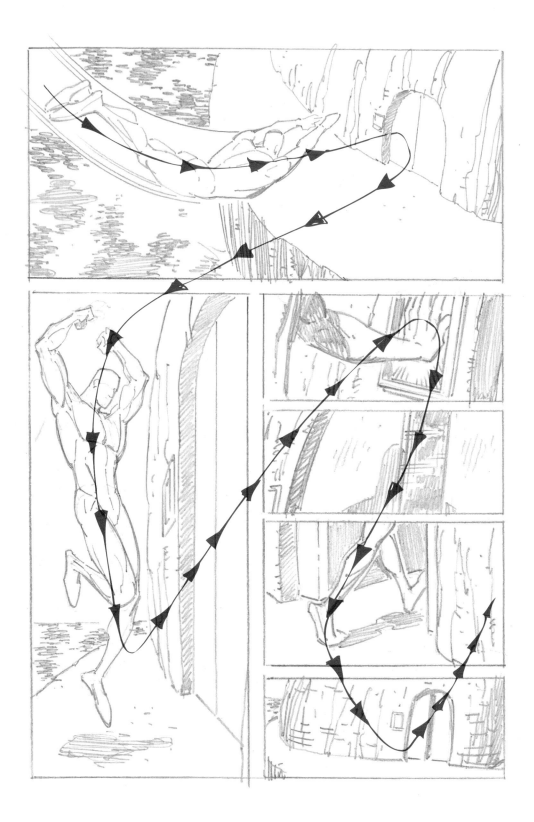

THE SCRIPT

There are two kinds of scripts a writer may give you: a full script and a plot. In a full script, the writer breaks the page down into panels and may even include the dialogue. In a plot, the writer provides just a paragraph detailing the actions for the page and leaves the shots up to you. A plot rarely includes any dialogue.

The examples of a full script and plot that follow were written by Ron Marz, one of today's best comic book writers.

Full Script

Panel 1: Long shot to establish location. We're in the rain forests of Mexico's Yucatán peninsula, looking over the treetops at a group of Mayan ruins. The ruins aren't as excavated and tourist-friendly as those in Chichén Itzá. This is more like the site at Palenque, or in Tikal in Guatemala—more mysterious and ancient. The sun is just beginning to rise behind the ruins, giving the whole scene a moody atmosphere. To add some depth, let's have a lizard on a branch in the foreground.

Panel 2: Now we cut inside one of the Mayan temples, although this won't be evident to the reader yet. This panel should show a close-up of Monarch, shot from a slightly low angle so we're looking up at him, making him that much more imposing. His face is lit rather severely by a strong off-panel light source. His expression is a triumphant leer, made more menacing by the moody lighting.

Panel 3: This should be the largest panel on the page. I'm thinking of a slightly high-angle shot so we're looking down from an elevated position and getting a fairly expansive view. We're still inside the temple, finally pulling back enough to reveal the setting. We're in an underground Mayan ceremonial chamber, the walls covered with relief carvings of Mayan design. There are no windows. The room isn't huge but should still be big enough to be impressive.

Monarch is at the center of the room, looking large and imposing. Next to him is a large machine of fanciful design—you're not quite sure what the thing does, but it's definitely imposing, probably larger than Monarch himself. The machine is mostly metal with some clear areas through which radiates a strong blue light, as if the device contained incredible power. This blue light is what lit Monarch so strongly in the previous panel, and

is in fact lighting the whole scene. It casts the wall carvings into sharp relief, giving the place a kind of spooky feel. Obviously, Monarch is up to no good with this incredible machine.

Near Monarch and the machine we see Apollo, who's had better days. He's actually a prisoner and is hanging spread-eagled in the air, "shackled" to a gridlike energy pattern that Monarch created. Apollo is bound to this energy pattern by the wrists and ankles, held fast. His manner is unbowed; in fact, he's straining to free himself, but to no avail. Monarch is brandishing a fist at Apollo, a triumphant smile on his face; he believes victory is finally at hand. If possible, Apollo should be placed toward the right side of the panel as he'll be speaking last, snarling his defiance at Monarch.

Panel 4: This panel is dominated by a medium shot of Monarch. He's smug, almost cocky. He's about to press a button or pull a lever on the machine, some sort of triggering device. He's confident of victory and says as much. Behind Monarch, however, we see that an inky blackness has appeared in mid-air and is starting to spread. Monarch is oblivious to this.

Panel 5: Penumbra has transported in, and we reveal her in all her glory. The inky blackness, of course, heralded her arrival and she simply appeared from within it; a nimbus of that blackness still surrounds her. She looks tough and ready, definitely meaning to put a stop to Monarch's plans. As for Monarch, he's basically a framing device in the left foreground. He's turning to behold Penumbra, looking into the panel with a shocked expression on his face. Note that he has not yet triggered the device.

Plot

We open on Mayan ruins in the Mexican jungle at dawn. We cut inside the ruins, to an underground chamber, and see a triumphant Monarch with a fancifully designed doomsday weapon. A defiant Apollo is at Monarch's mercy, imprisoned in an energy grid and powerless to stop him. The villain is about to trigger the weapon when Penumbra appears via her inky transportational power, totally catching Monarch off guard.

As you can see, there is a big difference between a plot and a full script, but both get the job done. For this example, I chose to work from the full script.

DRAWING THE PAGE

It's now time to put everything you've learned together and actually draw a comic book page. In this section, we'll follow the development of a page through three basic steps:

• The model sheet

• Thumbnails

• Pencils (rough pencils, breakdowns, and finished pencils)

The Model Sheet

Whether you're creating new characters from your imagination or interpreting preexisting characters, you'll need to define a body type and final costume for each. Characters can be interpreted an infinite number of ways, so it's important to establish these details beforehand. The drawings that follow, for example, show how differently I and eight of today's hottest professionals interpreted the character Apollo.

Drawing by yours truly. I did this in the popular Japanese "Manga" style. Joe Madureira is known best for drawing in this style.

Drawing by Jeff Campbell.

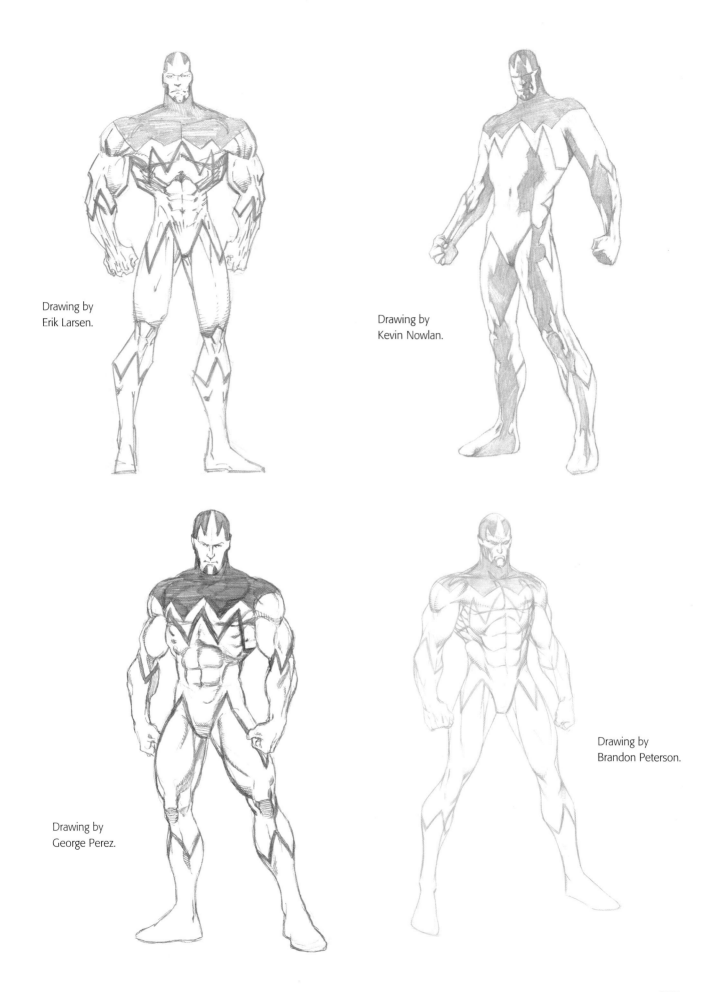

Drawing by
Erik Larsen.

Drawing by
Kevin Nowlan.

Drawing by
George Perez.

Drawing by
Brandon Peterson.

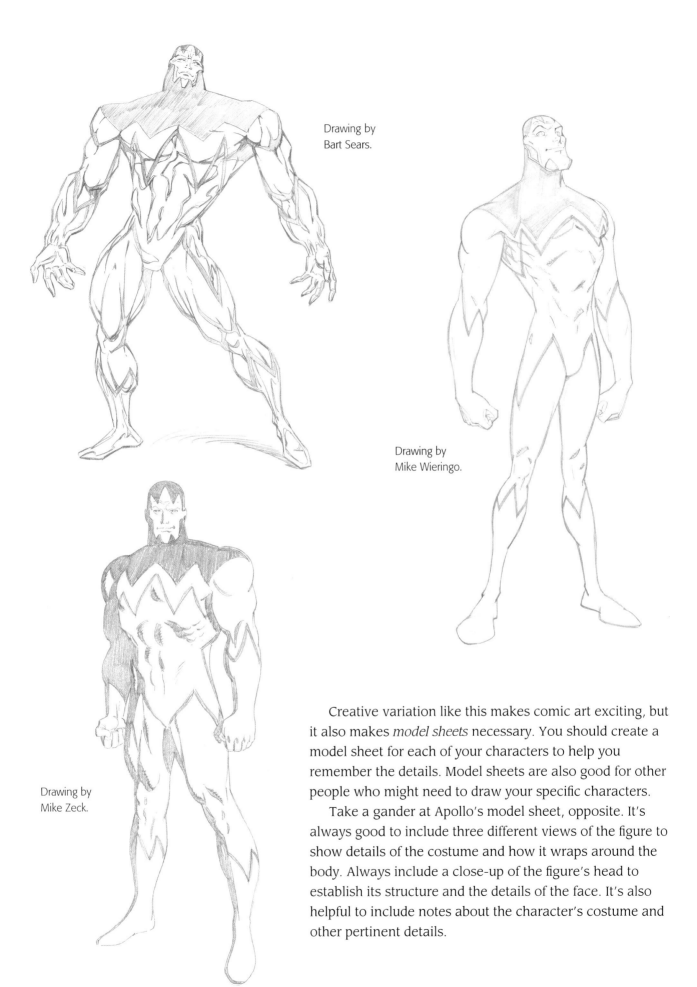

Drawing by
Bart Sears.

Drawing by
Mike Wieringo.

Drawing by
Mike Zeck.

Creative variation like this makes comic art exciting, but it also makes *model sheets* necessary. You should create a model sheet for each of your characters to help you remember the details. Model sheets are also good for other people who might need to draw your specific characters.

Take a gander at Apollo's model sheet, opposite. It's always good to include three different views of the figure to show details of the costume and how it wraps around the body. Always include a close-up of the figure's head to establish its structure and the details of the face. It's also helpful to include notes about the character's costume and other pertinent details.

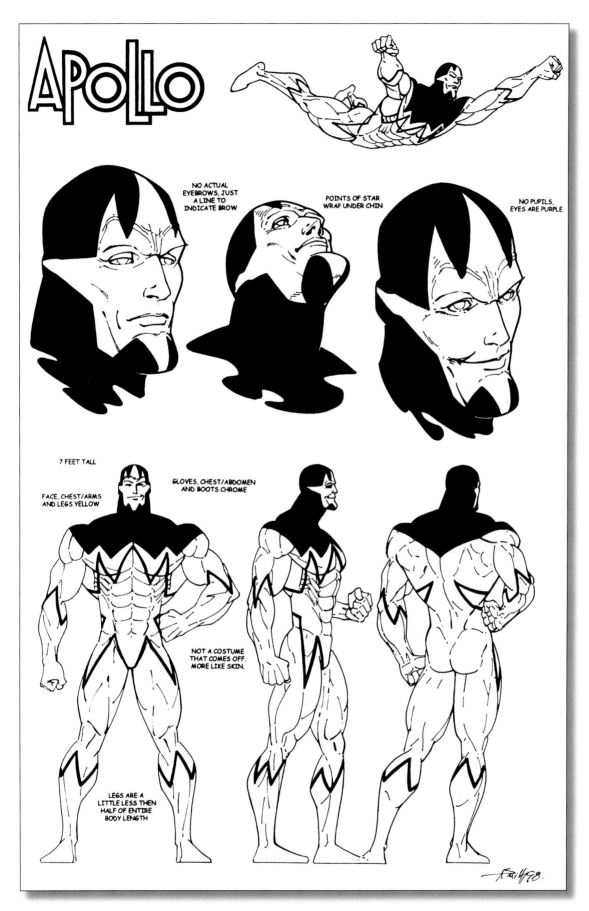

A model sheet for the character Apollo.

Thumbnails

A thumbnail is a very small drawing of the page, often only one inch wide and one and a half inches tall. You use thumbnails to play around with panel design and layout, and to figure out which areas of the page should be kept light versus dark. Thumbnails should be kept very small and sketchy; you don't want to get caught up in the drawing of the page. All you want is to figure out how to place and size the elements for a balanced design.

Here are the three thumbnails I did for this page, shown at their actual size. I chose the rightmost thumbnail to work with because I liked how the first panel gives an expansive view of the setting. I especially liked this thumbnail's third panel, a nice bird's-eye shot that gives all the information the writer had wanted. Of the three, this thumbnail also seemed the most dramatic and visually exciting.

Pencils

Once you've decided on a basic layout and design for your panels, you can start working on a full-sized page. Most comics are drawn ten inches wide and fifteen inches tall on two-ply Bristol board.

There are three basic stages to penciling: rough pencils, breakdowns, and finished pencils, as shown on pages 119–121.

I'LL PENCIL YOU IN, BABY!

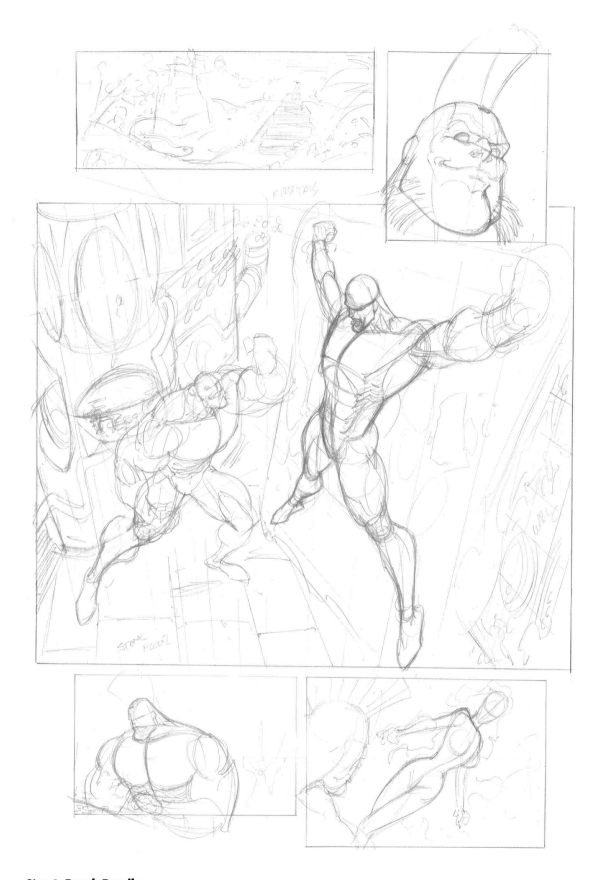

Step 1: Rough Pencils

This is when I start roughing in a full-sized page. The drawing should be loose and scribbly; you're just trying to capture the feel and gesture of the page.

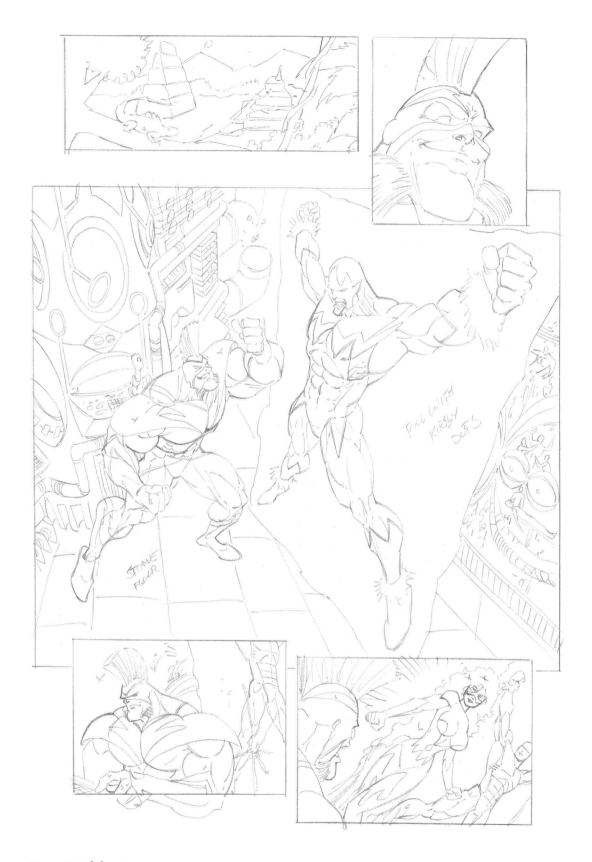

Step 2: Breakdowns

Use a light box to trace the rough pencils onto another board, cleaning the drawing up and adding costume and other details as you go. You should end up with a nice crisp page, but with no lighting added—just good drawing.

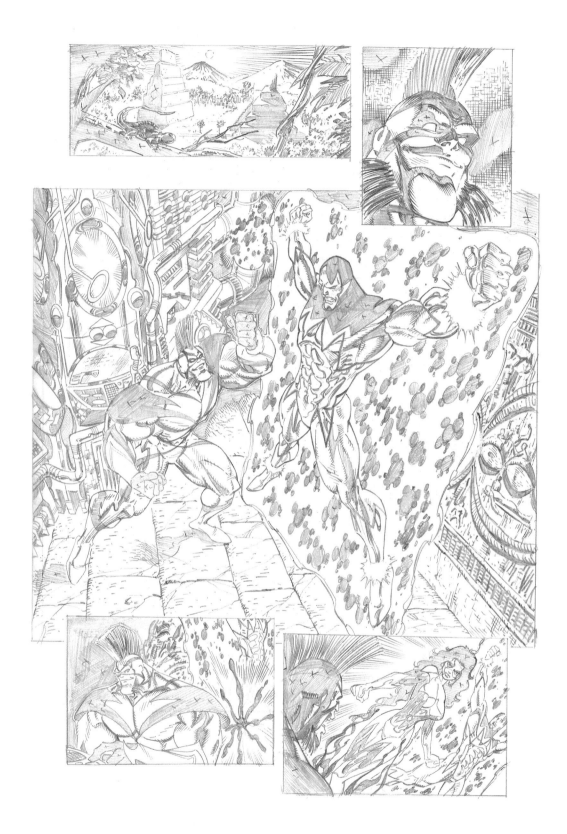

Step 3: Finished Pencils

Finally, go in and add the lighting and rendering. This is the process that usually takes the longest, but in the long run is well worth the time.

Being an inker is more than just taking black ink and tracing over pencils, no matter how "tight," or exact, the pencils might be. An inker establishes depth in a drawing, gives the drawing life, and contributes to the storytelling. Most good inkers I know also know the rules of good drawing. In other words, a good inker isn't just someone who can "pull," or draw, nice lines, but someone who also knows proper construction and form.

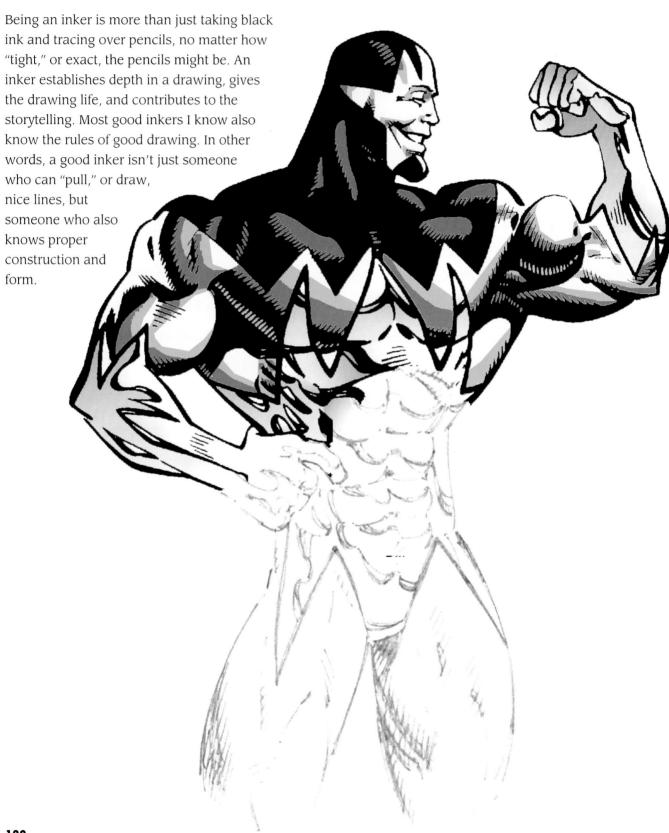

TOOLS OF THE TRADE

The following is a list of tools used by most inkers. Experiment with different brands and tools to see which you prefer.

- **Inking brushes.** I like to use Winsor & Newton Series 7 #2 and Raphaël (orange barrel) 8404 #2 brushes. Some people prefer brushes that are larger or smaller; experiment to see what works for you.

- **Crow quill pens.** The Hunt 102 crow quill is probably the one most commonly used. Check out the selection in your local art store and experiment with different sized nibs.

- **Rapidographs/technical pens.** Just recently I started using Sakura Pigma Micron pens. Their ink is permanent and won't bleed or fade.

- **Straightedges, templates, and French curves.** You'll need these for making straight lines, circles, and ellipses.

- **Ink.** I suggest using black India ink. There are many brands on the market: Higgins Waterproof Black India Ink is a good one, as is Koh-I-Noor Ultradraw Waterproof Ink. The important thing is that the ink be waterproof.

- **Correction fluid.** You'll need white correction fluid to fix mistakes. Check your local art store for different brands.

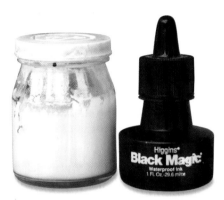

Higgins ink and a jar of correction fluid.

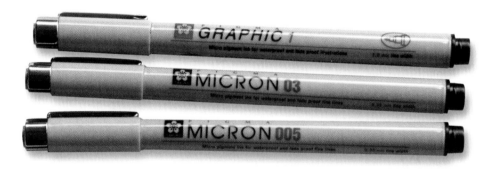

These Sakura Pigma Micron pens have permanent ink that won't bleed or fade.

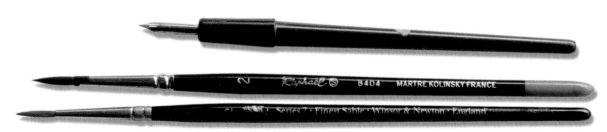

Three of my tools of choice: a Hunt 102 crow quill pen (top), a Raphaël 8404 #2 brush (middle), and a Winsor & Newton Series 7 #2 brush (bottom).

USING YOUR TOOLS

Once you get the proper tools, practice using them to pull various types of lines, from thin and light to heavy and thick. You can also practice making "burst lines," which are usually used to indicate a bright light or the force of a dramatic impact.

　　Don't get discouraged if at first you feel clumsy; it takes lots of practice. I started using a brush to ink with when I was fifteen years old and I still practice my brush strokes on scrap paper. Look at the different types of strokes below and practice reproducing them on your own.

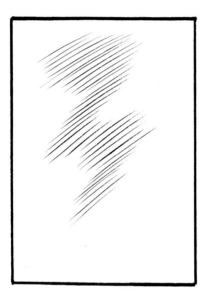

These light, airy strokes were done with a Raphaël 8404 #2 brush.

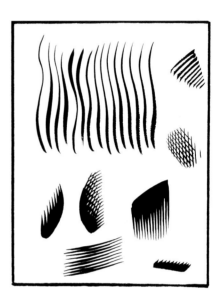

These strokes were done using the same Raphaël brush, but notice how much darker and stronger they are. Don't worry about making perfect lines at first; just try to get comfortable using the tool.

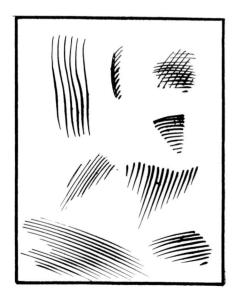

I pulled these strokes with a Hunt 102 crow quill pen. I used a French curve to do the slightly curved strokes in the lower left-hand corner.

Here are some examples of burst lines and fades using the Hunt crow quill pen and a ruler. Remember: practice, practice, practice.

It's best to learn how to use both pens and brushes. There are no set rules about which tools you should use and when; use your own judgment for each individual project. The next few examples show you how the same figure (in this case, Apollo) looks when inked with various tools.

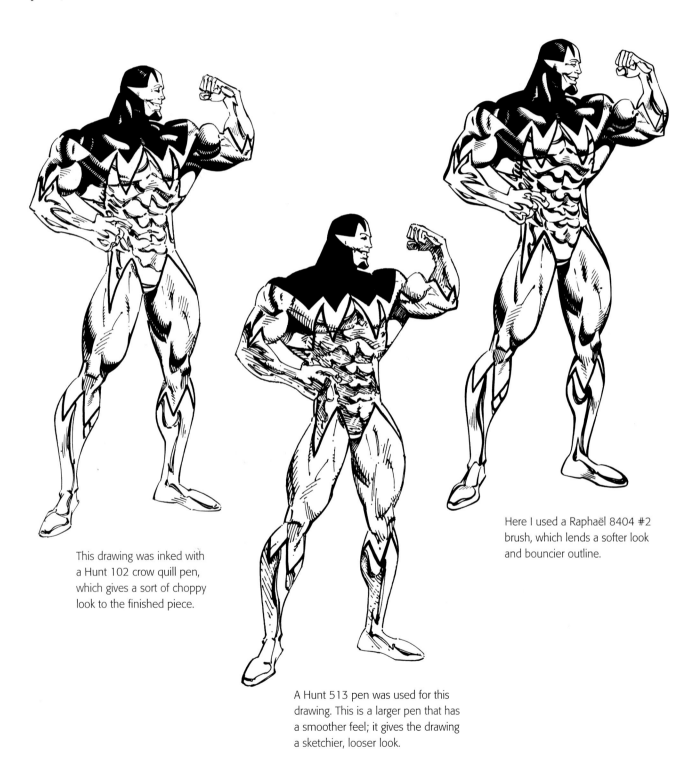

This drawing was inked with a Hunt 102 crow quill pen, which gives a sort of choppy look to the finished piece.

A Hunt 513 pen was used for this drawing. This is a larger pen that has a smoother feel; it gives the drawing a sketchier, looser look.

Here I used a Raphaël 8404 #2 brush, which lends a softer look and bouncier outline.

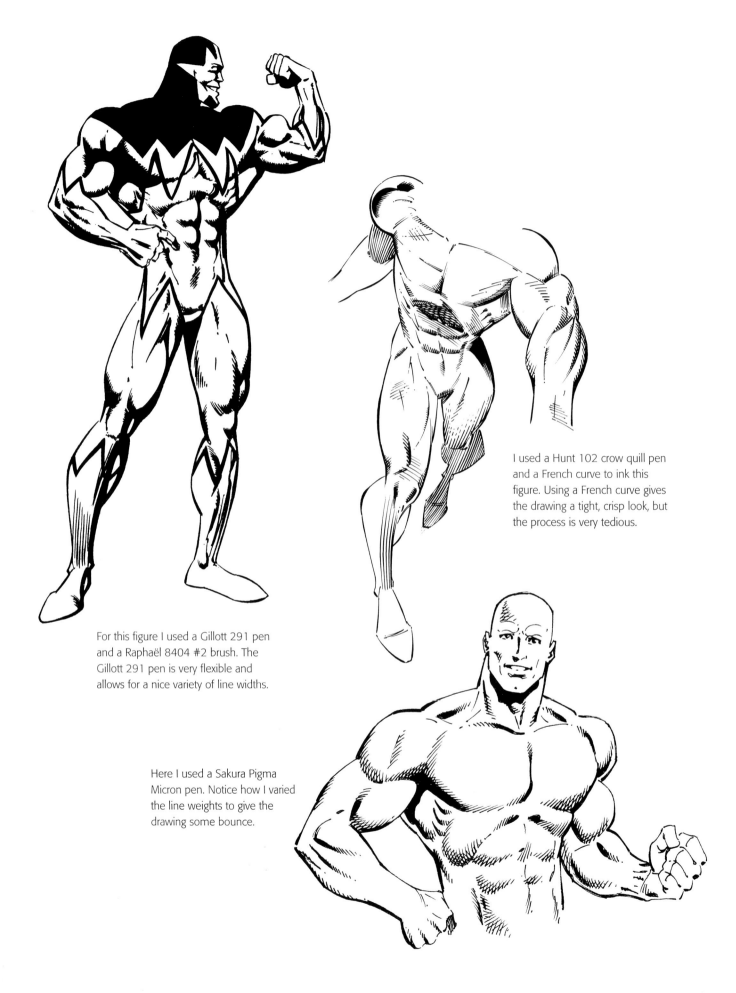

I used a Hunt 102 crow quill pen and a French curve to ink this figure. Using a French curve gives the drawing a tight, crisp look, but the process is very tedious.

For this figure I used a Gillott 291 pen and a Raphaël 8404 #2 brush. The Gillott 291 pen is very flexible and allows for a nice variety of line widths.

Here I used a Sakura Pigma Micron pen. Notice how I varied the line weights to give the drawing some bounce.

INTERPRETING PENCILS

The pencils you are given may be "tight" or "loose." Tight pencils are detailed and definite. They are drawn with all the line weights and rendering indicated and the black areas filled in. Loose pencils, on the other hand, leave some room for interpretation. Loose pencils might, for example, be drawn with sketchier lines that allow the inker more control over line weight.

No matter how tight or loose an artist's pencils, try to stay as close to that person's style as possible. As an inker, it's not your job to redraw someone else's work (unless you are told to by an editor). I wouldn't want an inker to redraw my work, so I won't redraw someone else's.

To demonstrate the transition from pencils to inked figure, I inked four of the pencil drawings of Apollo from Chapter 6, shown below and on pages 128–130. Some of these were very tight, others looser. Look at each inked figure and compare it to the earlier pencil stage.

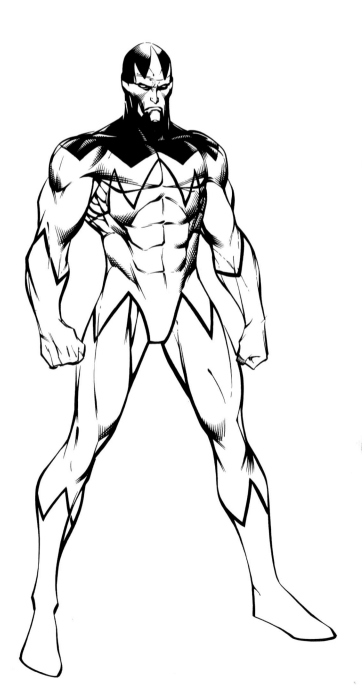

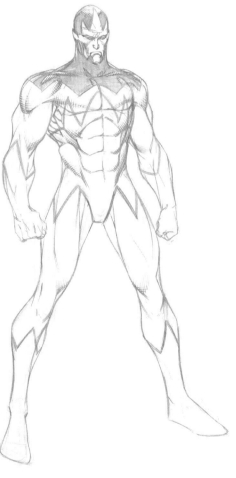

This figure was penciled by Brandon Peterson. Brandon's pencils are super tight and there's not much room for interpretation, but as the inker you still need to think about what you're doing. Never just trace over the pencils. I inked this figure entirely with brush.

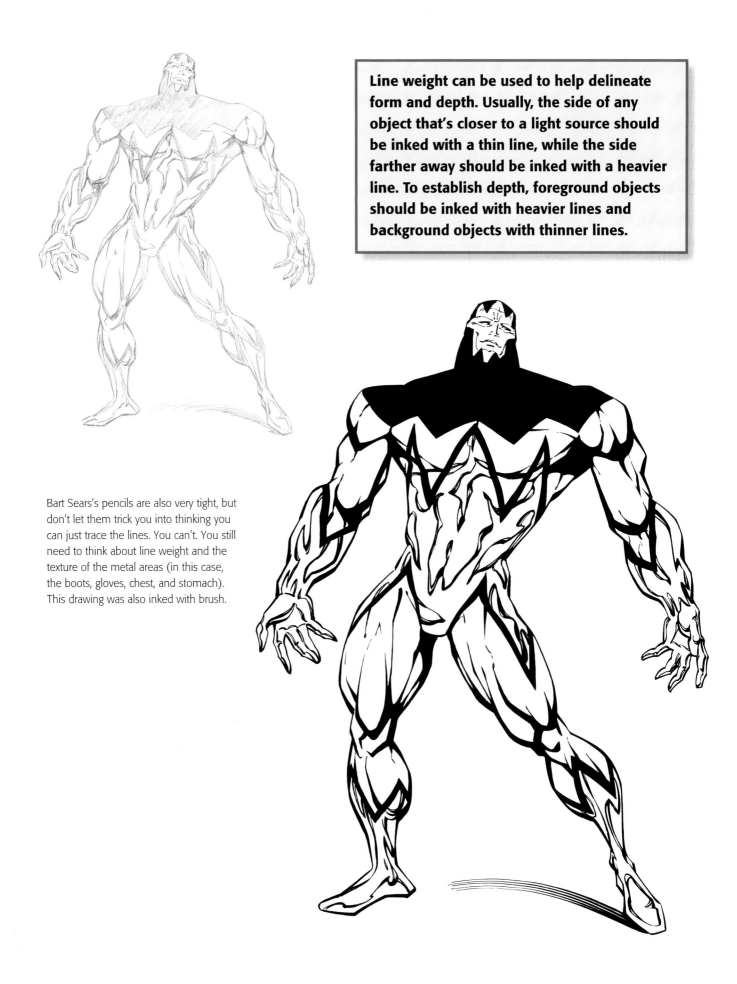

Line weight can be used to help delineate form and depth. Usually, the side of any object that's closer to a light source should be inked with a thin line, while the side farther away should be inked with a heavier line. To establish depth, foreground objects should be inked with heavier lines and background objects with thinner lines.

Bart Sears's pencils are also very tight, but don't let them trick you into thinking you can just trace the lines. You can't. You still need to think about line weight and the texture of the metal areas (in this case, the boots, gloves, chest, and stomach). This drawing was also inked with brush.

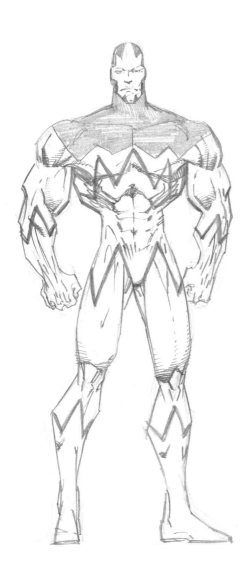

Erik Larsen's pencils are fairly tight, but there is still a lot to interpret. Notice, for example, the sketchy construction lines for the shoulders and for the rendering above the knees. The inker has to make some decisions to pull this piece together. I inked this piece with a Gillott 291 pen.

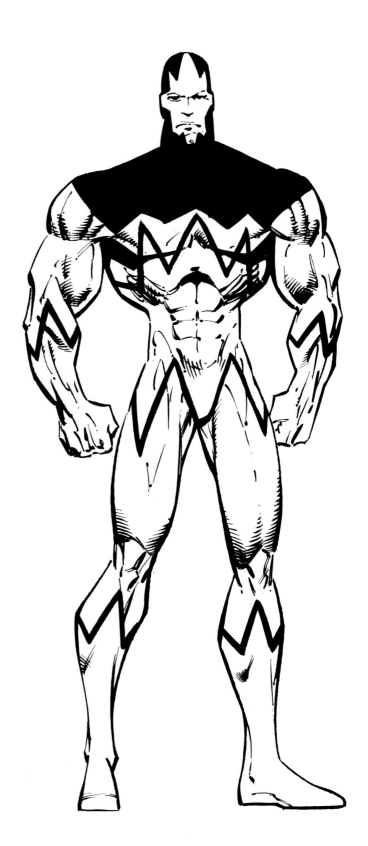

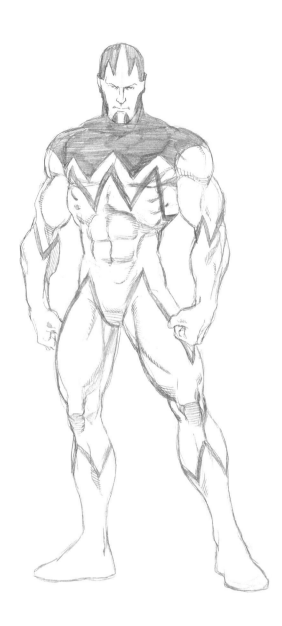

I wanted to give George Perez's pencils a softer look so I chose to ink them with brush. This was a fun one to ink because George's pencils aren't very light, leaving some room for interpretation. For example, notice the rather sketchy lines George used to indicate the abdominal muscles. It was my job as the inker to interpret and clean these lines to show the muscles' forms more clearly.

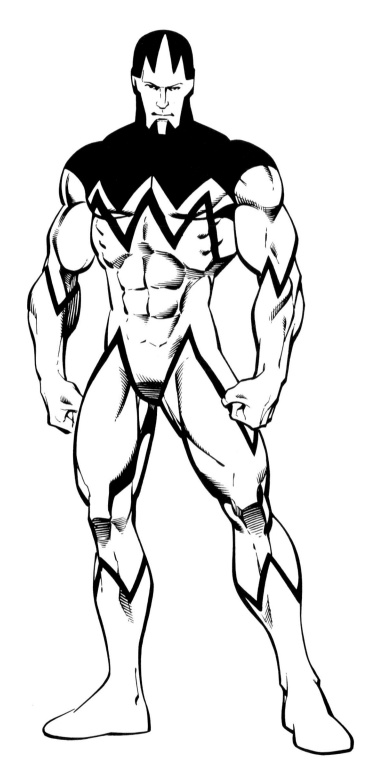

Inking Breakdowns

Sometimes you may not be given finished pencils to work with at all, but only breakdowns. As you may remember from Chapter 6, breakdowns are pencils that have not yet been given lighting or rendering. You would then be responsible for creating *all* the lighting and depth in the panel.

The examples below show ways to create depth in a landscape scene, but the same techniques could be used for any breakdown.

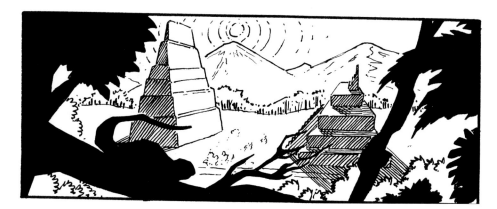

You may recognize this panel: It was on the page I penciled in Chapter 6. Here I've created depth by making forms closest to the viewer solid black, then going progressively lighter as we move back in space. Notice how the trees and lizard in the foreground are black, the mid-ground is in gray tones, and the background is entirely free of grays and blacks.

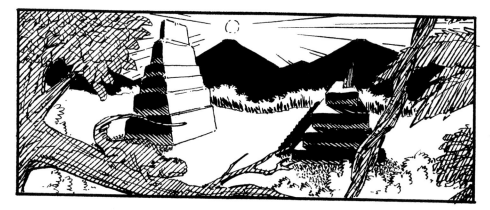

In this example I used solid black for the objects farthest away (the mountains), a little bit of gray and black for the mid-ground (the Mayan temples), and an even gray tone for the foreground (the trees and lizard). The gray tone gives the foreground a blurred quality and focuses our attention on the main part of the panel.

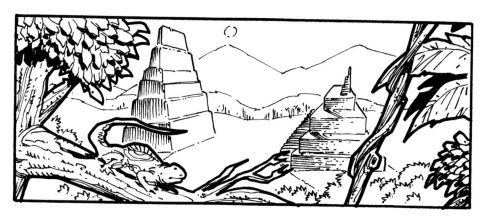

Another way to establish depth is by varying line weight. Notice how I inked the foreground with heavy outlines and the mid-ground with lighter outlines and less detail. The background is inked with an even lighter outline and without any detail at all. This style is fine but I wouldn't suggest it unless you know whether the person coloring your page is good. A bad colorist could ruin this panel.

INKING WITH THE EXPERTS

There are as many ways of inking a page as there are artists, so I asked a group of professional inkers (including myself) to each ink the page from Chapter 6, then walk you through his approach in his own words. Try each technique, then experiment to see what works for you.

Andy Smith

I usually start with the first panel and then work my way down the page, completing each panel before moving on to the next. For this page, I used a combination of brush and pen.

The first panel was mostly done with a Hunt 102 pen, which I prefer over brush for inking trees and stone because it produces a harder, crisper look. I went back in with correction fluid to create the branches in the foreground that overlap the temple on the right-hand side. I then used a brush to fill in the blacks. For the second panel, I used a brush for Monarch's head and a 102 pen and ruler to create the background texture.

The third panel has a lot going on, so I tackled it foreground to background. I started with Apollo's figure, which I did entirely with brush, even the face. For the big machine behind Monarch, I used Micron Pigma markers and various ellipse templates, French curves, and straightedges. The last two panels used a combination of all the tools mentioned earlier.

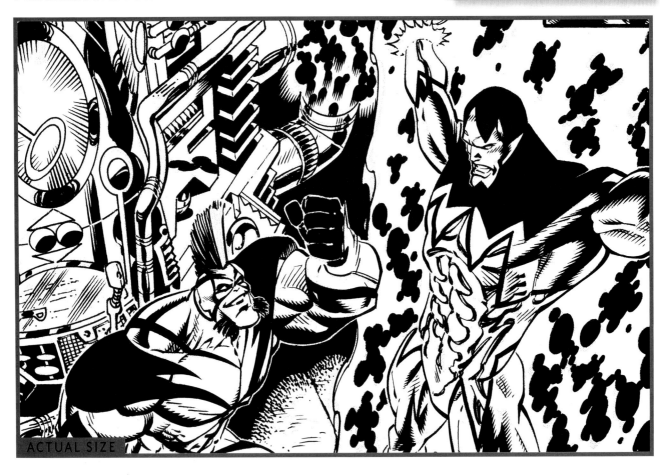

ACTUAL SIZE

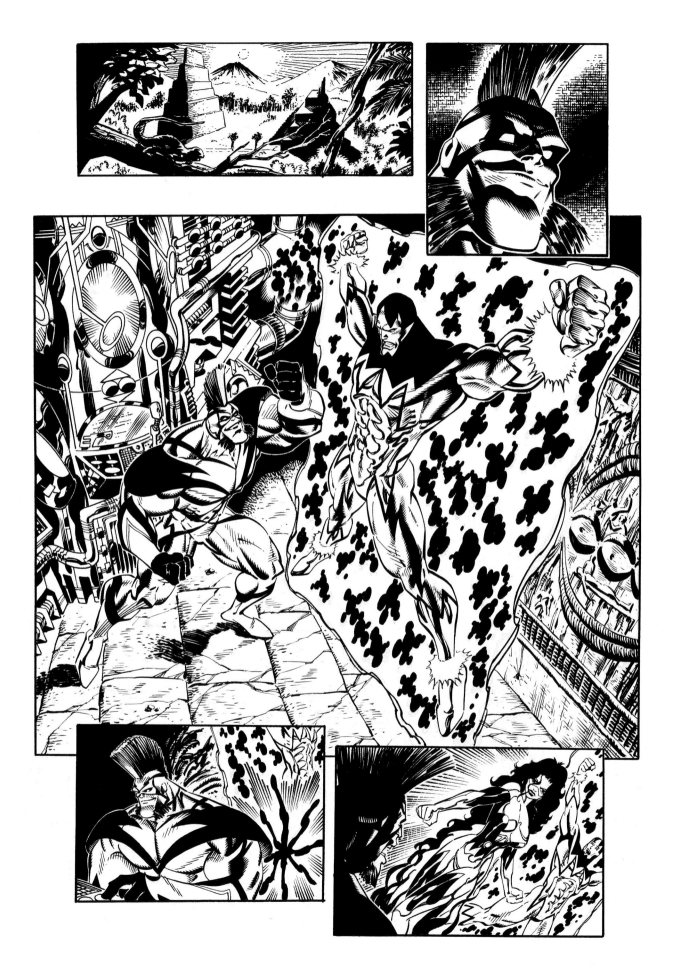

Terry Austin

I generally start inking a page from the bottom right-hand corner and move upward so as not to smear the pencils any more than they might already be. I then tackle each panel one at a time until it's completed, black areas and all. For each panel, I start with objects in the foreground, then move on to those in the middle ground and finally the background. This method allows me to work depth into the panel by tackling one plane at a time.

I was unfamiliar with Andy's characters, so I'm pretty sure I got some of their costume details wrong. If this had been an actual page of a comic book, I'd have phoned the editor and asked for some kind of reference or model sheet for these folks. Never be afraid to do the same.

I don't like to get specific about the tools I use to ink because what does one thing in my hand will do something entirely different in yours. Beginners are best served by trying everything in the art store and then discarding anything that doesn't produce the desired effect. Okay, here's one hint: I use a quill pen point for line work and a brush to fill in black areas. That's it; my lips are sealed.

MATERIALS USED

- **quill pen**
- **brush**
- **black waterproof India ink**
- **markers**

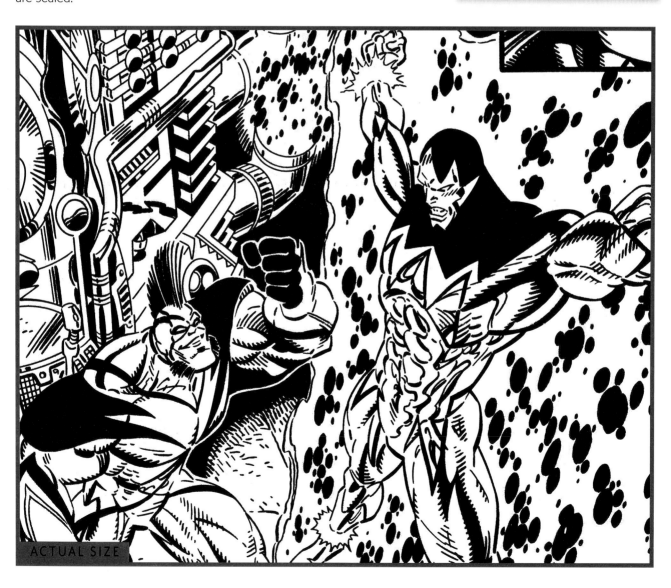

ACTUAL SIZE